MW01079501

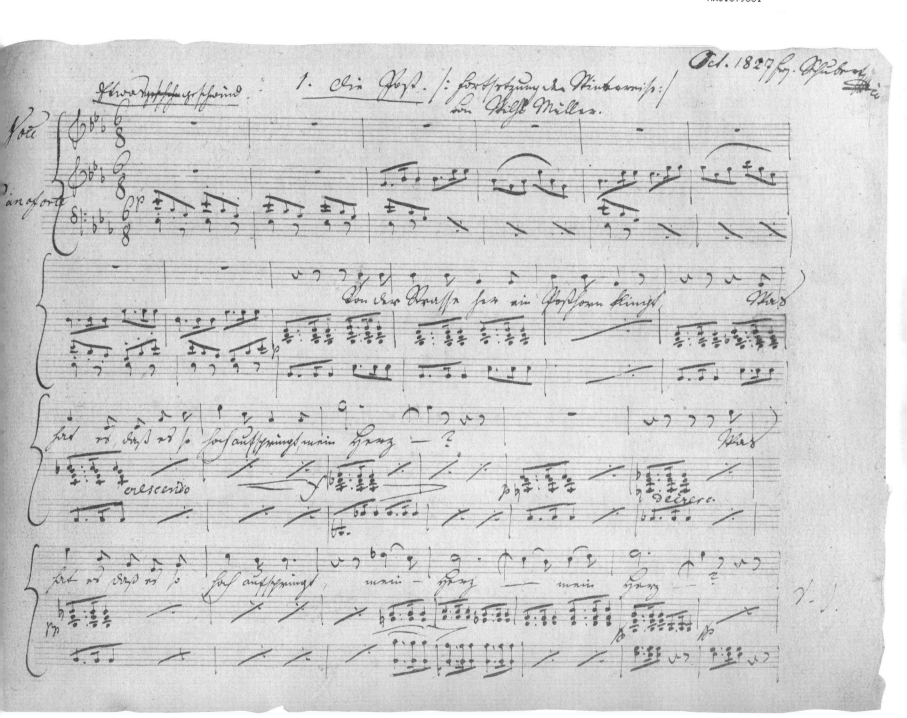

Schubert's

Winterreise

Schubert's Winterreise

A Winter Journey
in Poetry, Image, & Song

Poems by Wilhelm Müller
Translated by Louise McClelland Urban

Foreword by John Harbison
Essay by Susan Youens

Photographs by Katrin Talbot

Companion compact disc
Paul Rowe, baritone
Martha Fischer, piano

THE UNIVERSITY OF WISCONSIN PRESS
IN COLLABORATION WITH
THE UNIVERSITY OF WISCONSIN–MADISON
SCHOOL OF MUSIC

John b. el d. Cooper
Georgetown, Texas
31 December 2007

Publication of this book has been made possible in part by the generous support of The Evjue Foundation, Inc., the charitable arm of *The Capital Times*.

The University of Wisconsin Press
1930 Monroe Street
Madison, Wisconsin 53711

www.wisc.edu/wisconsinpress/

3 Henrietta Street
London WC2E 8LU, England

Copyright © 2003
The Board of Regents of the University of Wisconsin System
Translations copyright © 2003
Louise McClelland Urban
All rights reserved

5 4 3 2 1

Printed in Canada

Library of Congress Cataloging-in-Publication Data
 Schubert's Winterreise : a winter journey in poetry, image, and song /
 poems by Wilhelm Müller ; translated by Louise McClelland Urban ;
 foreword by John Harbison ; essay by Susan Youens ; photographs by Katrin Talbot.
 p. cm.
 "Companion compact disc: Paul Rowe, baritone; Martha Fischer, piano."
 Includes bibliographical references.
 ISBN 0-299-18600-8 (cloth : alk. paper)
 1. Schubert, Franz, 1797–1828. Winterreise. 2. Müller, Wilhelm, 1794–1827—Criticism and
interpretation. I. Müller, Wilhelm, 1794–1827. II. Urban, Louise McClelland. III. Harbison, John.
IV. Youens, Susan.
 ML410.S3 S29976 2003
 782.4'7—dc21 2002156545

Contents

Acknowledgments

The following people were instrumental in making this project a reality:

Caroline Beckett
Carolyn Hague
Bill Lutes
Frank X. Sandner
John Schaffer
Sarah Schaffer
Gerhard Urban
John Wiley

Foreword

*M*any composers have written very serious pieces and brought news that is painful and shocking to hear. Why is Schubert in his *Winterreise* or in his *E-flat Trio*, in his *Schwanengesang* songs, in his *F-minor Fantasia* for four-hand piano—in *so many* pieces, not all of them from his last year—in so many ways the hardest to take?

He is fearless. He is not sentimental. He won't garnish or prettify his truth. He is not "personal" in any conventional Romantic sense.

When Schubert turns to look at the sign in "The Signpost" he is not afraid, he is not weeping, he is not indecisive or attractively confused. He is an objective reporter. Here is his news: none of us will escape. Nor can we turn back. Speaking to us in the last part of this song, this gregarious, late-drinking, ultimately isolated artist is reduced to a blank monotone, driven by a harmony both inexorable and impassive, saying that there is *nothing* on the other side, not consolation, not compensation, not the friends and confirmation you have lacked or lost, just a void, as deep and fathomless as the human soul can imagine.

And he tells us about this with a straightforwardness, a seeming artlessness, even a reluctance that bars escape.

All through his creative life Schubert stepped up to his subject matter with a kind of naive courage. If Beethoven had written an inventive, brilliantly successful *Septet*, no way round it but to make an even more inventive, structurally more ambitious *Octet*. If his predecessor had expanded the proportion, sonority, and ambition of symphonic writing, why not go even further with a grand symphony in C major? If piano trios like Beethoven's in B-flat and E-flat made that medium a vehicle for

symphonic statements in chamber music, how about an hour-long piece in E-flat that to this day is still the rangiest, most metaphysically probing piece of chamber music we have.

This takes us back to *Winterreise*. Throughout his career as a songwriter Schubert was periodically drawn to texts about not belonging or connecting. Somewhere in his final eighteen months he understood why. His own fate, as he tells us in his music, had become known to him. Fortunately for us, and for him, the telling still brought him in touch with beauty. And even more fortunately, he was never interested in conventionally dramatizing his revelations. The drama—acted out in harmony, melody, and rhythm, is not voluntary. This is why it often erupts so violently. He regrets what he has seen, but will not retouch it.

This book reminds us that such a work of art must be heard and re-heard by each generation. And for our visual era, seen and re-seen. Katrin Talbot's photographs remind us what a wonderful graphic hand Schubert had. We've had no better musical draftsman than the one who showed us the dogs, the weathervane, the raven. The photographic images keep us uncomfortably close to the blunt specificity of Schubert's music, which is where we belong.

—*John Harbison*

A Wintry Geography of the Soul
Schubert's *Winterreise*

*T*hirty years after Franz Schubert's death on 19 November 1828, his friend Joseph von Spaun wrote the following account of the first time he heard *Winterreise*:

> For some time Schubert appeared very upset and melancholy. When I asked him what was troubling him, he would say only, "Soon you will hear and understand." One day he said to me, "Come over to [Franz von] Schober's today, and I will sing you a cycle of horrifying songs. I am anxious to know what you will say about them. They have cost me more effort than any of my other songs." So he sang the entire *Winterreise* through to us in a voice full of emotion. We were utterly dumbfounded by the mournful, gloomy tone of these songs, and Schober said that only one, "Der Lindenbaum" ["The Lindentree"], had appealed to him. To this Schubert replied, "I like these songs more than all the rest, and you will come to like them as well." ("Aufzeichnungen über meinen Verkehr mit Franz Schubert [1858]" in Otto Erich Deutsch, ed., *Schubert: Die Erinnerungen seiner Freunde* [Leipzig: Breitkopf and Härtel, 1957], 160–61)

Schubert was barely thirty years old when he composed this profound confrontation with ultimate things. No wonder his friends were taken aback: Conventional notions of lied loveliness have no place in this world of ice, snow, and grief. There is beauty aplenty, but it is the sounding analogue to Rembrandt's portraits of old age, with their similarly truthful refusal to shy away from what is darkest in existence. As we shall see, it took courage beyond reckoning for Schubert to set this poetry to music, because he saw in it his own possible fate, one of unimaginable bleakness. A great work assumes even greater power when one realizes what it must have meant to its creator.

He did not do it alone: It was a poet's words that brought this music into being. Schubert already knew of Wilhelm Müller (1794–1827) because it was in this poet's 1821 anthology with the

imposing title *Siebenundsiebzig Gedichte aus den hinterlassenen Papieren eines reisenden Waldhornisten* (Seventy-seven poems from the posthumous papers of a traveling horn player) that Schubert found the cycle *Die schöne Müllerin* (The beautiful miller maid) and set it to music in 1823. Müller, we learn from his biographers, was born in Dessau, near the banks of the Mulde River, and attended university in Berlin. His philological studies were interrupted after one year by the War of Liberation in 1813; Müller fought in four battles and subsequently had an affair in Brussels with a woman we know only as Thérèse, an episode that caused his father much concern and ended badly. When he returned to Berlin, he fell in love with the seventeen-year-old gifted poet Luise Hensel, and this idealized and largely undeclared love is the backdrop to the creation of *Die schöne Müllerin*. Müller's dreams of marriage to Luise ended when the great Romantic poet Clemens Brentano, twenty-one years her senior, declared his suit insistently and repeatedly (she never married). After travels in Austria and Italy from August 1817 to January 1819, Müller returned to his native Dessau and launched a six-fold career as town and ducal librarian, teacher, editor, translator (he translated Christopher Marlowe's *The Tragicall Historie of Doctor Faustus* into German), critic, and poet. He became famous as the "German Byron," who, like his more famous English contemporary, was a philhellene, a supporter of Greek independence from the Ottoman Empire; Müller's *Griechenlieder* (Greek songs) were conceived in part as a way of exalting freedom of speech from within a society notoriously inimical to the free expression of political ideas. In 1821, he married—happily—a young woman named Adelheid Basedow, the daughter of an educational reformer now remembered chiefly for his disputes with Goethe. One of their children, F. Max Müller, would grow up to become a famous scholar of Sanskrit literature at Oxford University, but he had little chance to know his father: Wilhelm Müller died unexpectedly on the night of 30 September 1827, perhaps as Schubert was completing the last of his labors on his second Müller cycle.

Müller's poetic cycle *Die Winterreise* grew in stages, and its complex creation would have curious consequences for the genesis of Schubert's music. (An important point, all too often transgressed: Schubert would omit the definite article from the poet's title, possibly because he wanted a starker, stronger, more austere name for his musical work. To be correct, one should always designate Schubert's D. 911 as *Winterreise* and Müller's poetic cycle as *Die Winterreise*.) On 16 January 1822, Müller sent his "Wanderlieder von Wilhelm Müller. Die Winterreise. In 12 Liedern" (Wandering songs by Wilhelm Müller. The winter journey. In twelve poems) to the publisher Friedrich Brockhaus in Leipzig for publication in the literary periodical

Urania: Taschenbuch auf das Jahr 1823 (Urania: Pocketbook anthology for the year 1823). It was evidently this source that Schubert discovered in late 1826 or early 1827, as the order of the poems corresponds exactly to part 1 of his setting:

> *Gute Nacht*
> *Die Wetterfahne*
> *Gefror'ne Tränen*
> *Erstarrung*
> *Der Lindenbaum*
> *Wasserflut*
> *Auf dem Flusse*
> *Rückblick*
> *Das Irrlicht* [once again, Schubert would omit the definite article]
> *Rast*
> *Frühlingstraum*
> *Einsamkeit*

In March 1823, ten additional poems appeared in another literary periodical, the *Deutsche Blätter für Poesie, Literatur, Kunst und Theatre* (German album-leaves for poetry, literature, art, and theater), edited by Karl Schall and Karl von Holtei. The complete cycle of twenty-four poems, with the addition of the last two poems Müller would add to his work, "Die Post" and "Täuschung," was published in the poet's second anthology, the *Gedichte aus den hinterlassenen Papieren eines reisenden Waldhornisten II: Lieder des Lebens und der Liebe* (Poems from the posthumous papers of a traveling horn player, vol. 2: Songs of life and love). This final version was the source for Schubert's *Fortsetzung* (Continuation, or Part 2), but Müller had changed the order of the poems as follows (the number in Schubert's ordering is given in parentheses after the title):

> *Gute Nacht (1)* *Im Dorfe (17)*
> *Die Wetterfahne (2)* *Der stürmische Morgen (18)*
> *Gefror'ne Tränen (3)* *Täuschung (19)*

Erstarrung (4)	*Der Wegweiser (20)*
Der Lindenbaum (5)	*Das Wirtshaus (21)*
Die Post (13)	*[Das] Irrlicht (9)*
Wasserflut (6)	*Rast (10)*
Auf dem Flusse (7)	*Die Nebensonnen (23)*
Rückblick (8)	*Frühlingstraum (11)*
Der greise Kopf (14)	*Einsamkeit (12)*
Die Krähe (15)	*Mut (22)*
Letzte Hoffnung (16)	*Der Leiermann (24)*

Why Müller shuffled the order at the final stage is anyone's guess, although the restless urge to revise his works was already a well-established habit. Certainly the most striking aspect of the final order is Müller's placement of what were originally numbers 9-12 in *Urania* ("Das Irrlicht," "Rast," "Frühlingstraum," and "Einsamkeit") much later in the *Waldhornisten* volume. Because the cycle traces thought processes and emotional states of being rather than a conventional plot narrative shaped by actions and reactions (this is another aspect of Müller's originality), it is likely that Müller was searching for the completion and ideal order of his cycle with each stage, arriving finally at the version in his second anthology.

According to Franz von Schober's reminiscences, Schubert discovered *Die Winterreise* in Schober's library, but Schober does not say when or which of the two sources—*Urania* or the *Waldhornisten* poems—Schubert found. Another Schubert friend, Fritz von Hartmann, wrote in his diary for 4 March 1827 about the composer's failure to appear at a soirée he himself had arranged, its purpose the unveiling of new compositions. Is it possible that Schubert's plans for the informal performance of his "completed" work (the *Urania* cycle of twelve songs) had been overturned by his discovery of the *Waldhornisten* poems in Schober's library and his subsequent realization that the cycle was not, in fact, complete? When one looks at the autograph manuscript of the cycle in the Pierpont Morgan Library in New York, one sees the word "Fine" (The end) written at the end of the twelfth song, "Einsamkeit," with a triumphal flourish, understandable after the effort recorded in the "working papers" that are songs 1–12—but it was not, in fact, the end. Whenever Schubert made the discovery of the complete poetic cycle, he evidently realized that he could not duplicate Müller's final ordering

without doing damage to the musical structure he had already created. Therefore, he simply set the remaining poems in order, beginning with "Die Post," although he reversed the order of "Mut" and "Die Nebensonnen" near the end. Despite periodic attempts by some performers to restore Müller's order to Schubert's cycle, it is possible to argue that Schubert devised a sequence as good as or even better than the poet's. This composer was one of the most astute readers of poetry in the history of song.

It is only recently, however, that Schubert has received the recognition due him for his literary acuity, and Müller is heavily implicated in earlier critiques of Schubert's choice of verse. Ever since the influential late-nineteenth-century Viennese music critic Eduard Hanslick condemned Müller for supposed cloying sentimentality, he has had bad press among musicians. But those who, like Hanslick, summed up the cycle as little more than a long string of laments over a sweetheart's unfaithfulness failed to recognize Müller's original permutation of a conventional Romantic subject: a journey by an isolated, alienated protagonist who has been rejected in love, a journey that ends with a tragic finale in madness or death. But the sustained outcry of scorched sensibility in *Winterreise* goes far beyond grief over loss of a sweetheart. The wanderer tells us in the first words of the first song, "Gute Nacht" ("Good Night"), that he came to this place a stranger and leaves still a stranger. Unable to bear his continuing alienation, not only from others but from himself, he embarks on an inner journey of self-discovery. Probing his wounded soul for answers to the mystery of his inner being, he asks himself one question after another, all of them variations on the ages-old existential queries, "Who am I? Why am I set apart from others? Why am I so alone? Where can I find meaning in the world?" We infer, from his bitter comment in the first song that God has made Love itself unfaithful, that he is an atheist, unable to find hope either in spiritual institutions (the Romantic recourse to mystical belief is no avenue for him) or in human bonds; something in his very nature separates him from society, despite his yearning for love and for the company of others. In the sixteenth song, "Letzte Hoffnung" ("Last Hope"), he even pins his desire for meaning onto a leaf, in whose fragility and inevitable downfall he finds his own image. Recognizing that all dreams—whether by night or by day—are wish-fulfillments, fantasy-deceptions incompatible with reality, he attempts to renounce illusion but discovers how difficult it is to do so when life has nothing hopeful to offer. Sorrow over lost love does not end there but leads the protagonist on a wintry inner voyage of discovery through the uncharted regions of the soul.

Readers familiar with Freud's "Mourning and Melancholia" might find in Müller's cycle a poetic version of the process Freud describes in his famous essay. Mourning begins with an exclusive devotion to the labor of grief, with loss of interest in the outside world and a turning away from anything not connected with thoughts of the lost love. Reality tells the mourner that the beloved no longer exists and that the attachment to the loved person, ideal, country, or cause must be withdrawn so that life may continue, but the mourner inevitably rebels and carries out the commands of reality only little by little over an extended period of time, immersing himself in memories he is reluctant to relinquish for fear of losing the beloved irrevocably. The wavering motion of a step forward into continued life, followed by a step backward into memory, is beautifully portrayed in the first half of Schubert's cycle: for example, the wanderer attempts to bury his love in the seventh song, "Auf dem Flusse" ("By the Stream"), in which he carves an icy tombstone as a memorial, but then flees back into reminiscence with "Rückblick" ("Backward Glance") just after. Even earlier, the wanderer realizes in the fourth song, "Erstarrung" ("Numbness") that without a tangible souvenir of his sweetheart he will inevitably forget her when the pain of loss is over. As yet unwilling to relinquish his memories of her, however painful, he searches frantically for traces of her footsteps in the snow, for the green grass and flowers that blossomed in this place when they were in love, but gives up when he understands that the search is futile. Successful mourning concludes with the self becoming free of its former total preoccupation with loss, but where melancholia is a factor, as it is in Müller's cycle, the process is prone to failure. From the start of the journey, the wanderer believes himself severed from all human bonds by an invisible "mark of Cain," some mysterious element that compels him to remain apart from the world. His heroic attempts to comply with the demands of reality are dashed on the rocks of a larger dilemma of identity.

As in all great works whose personae contemplate the gravest existential questions, Death is at issue. The grim reaper is all the more powerful a presence in *Winterreise* because the wanderer has no intention of seeking him out at the start of the journey. Rather, the desire for death rises unheralded from within and thereafter cannot be banished—indeed, it becomes an obsession in the last half of the cycle (in Schubert's ordering). The moment when Death first speaks to him from within is a turning point of the utmost importance and occurs in what is perhaps the most famous song in the cycle, "Der Lindenbaum." Indeed, this song became so popular that it was often extracted for inclusion, usually without the unfolklike setting of the fifth stanza, in *Commersbücher*, or books of student- and folk-songs. The wanderer's futile search for a souvenir of

his past love, a flower or a fragment of the grassy bank, in the fourth song, "Erstarrung," leads him to another green memory in "Der Lindenbaum": a remembrance of the linden tree that had been his refuge in the past. The choice of tree was calculated. The linden has a long history in German literature as the traditional site for lovers' rendezvous and a symbol of all that is gentle and beneficent in Nature; one thinks of the thirteenth-century Minnesinger (poet-singer of courtly love) Walther von der Vogelweide and his famous song, "Under der Linden" (Under the linden). In Müller's cycle, the murmuring sounds of the linden leaves seem like voices that say to the wanderer, "Come here, dear friend; you'll find repose with me." Because the sound is so sweet, he becomes all the more aware of the cold and the darkness, the sting of the icy wind in his face. And yet, when his hat blows away in the storm, he does not turn back to retrieve it but presses onward with his journey/life, without knowing why he does so. (There is an implicit gap both of time and space between stanzas 5 and 6 of this poem.) What he realizes at the moment when cold winds blow in stanza 5 ("Die kalten Winde bliesen . . .") is that the linden's soft invitation is a beckoning to death: the only way to become one with Nature is to die. The siren voices from within that murmur of rest and peace in death haunt him thereafter.

The lengthy piano introduction to Schubert's setting of "Der Lindenbaum" is a telling example of Schubert's close, imaginative reading of poetry. This introductory passage can be heard as the instrumental script for a sequence of events within the mind, a wordless process that subsequently leads to the articulation of memory in words. The wanderer first hears a rustling sound in the first two measures (this is a variation in another key of the "rustling" triplets in the right-hand part throughout "Erstarrung"), ending with an enigmatic fragment—two pitches (C-sharp and B) hanging in midair—whose implications are only explained later in the song. When the rustling resumes at a higher plane in measure 3, the wanderer is more fully aware of its presence, and therefore the phrase is both extended and marked by indices of disquiet and agitation. The passage leads downward and culminates in hymn-like chords, a built-in slowing-down of the motion as memory submerges the wanderer. These chords in turn end with echoing horn-call figures, evocative of wandering huntsmen in folkloric German forests, and by extension, of idealized Romantic memories of the past. Schubert's music thus traces the dawning awareness that precedes Müller's words, from the first stirrings of memory to agitated full consciousness, then a surrender to recollections of the past. An entire drama within the mind transpires before a single word is sung.

This cycle has as one essential theme the tenacity of unwanted life, or the difficulty of dying when one wishes. After memory of the lost beloved has loosed its hold on him, the wanderer in part 2 longs repeatedly for death. In the fourteenth song, "Der greise Kopf" ("The Aging One"), nocturnal frost has dyed the wanderer's black hair gray, and he believes that he has become miraculously old and near to death. (This reference to black hair is the only physical characteristic Müller ever reveals about the lone character in this cycle, and it tells us that the wanderer is still relatively young, if perhaps not as youthful as the miller lad in *Die schöne Müllerin*. We are inducted with great specificity into every twist and turn of his thoughts and feelings, but we never know his name, his occupation, his background, his schooling, his history. Such things do not matter in the wintry universe of this cycle.) When the frost melts, the bereft wanderer laments his distance from the grave. In the next song, "Die Krähe" ("The Crow"), the wanderer notices a crow flying in circles above his head and hopes that it is an omen, that the bird will be "faithful unto death"—a bitter quotation of the marriage service. The realistic wanderer does not name the agent of death because there is no present danger or circumstance that might promise his demise. Instead, he moves in imagination beyond the moment and means of death to a vision of his body as carrion for avian predators. In the twenty-first song, "Das Wirtshaus" ("The Inn"), the wanderer comes to a cemetery with funeral garlands of evergreen branches and fancies that it is an inn offering him hospitality and rest in death. Müller took his images from life: innkeepers in nineteenth-century Germany and Austria would hang wreaths on their doors as a sign to customers that the new wine, or Heurige, was available. Evergreen boughs, antique symbols of the immortality of the soul, are funerary emblems in many countries, and Müller's merging of these green tokens of death (and one remembers the wanderer's earlier longing for something green in the midst of icy desolation) with the traditional sign of Heurige hospitality is one poignant detail among many. But the "unmerciful innkeeper" turns the wanderer away from the inn, and he must once again resume his journey. And yet we notice that he never contemplates suicide. The tragedy is all the deeper because something—what, he does not know—chains him to this unwanted life.

The moment of revelation, when the wanderer finally understands his fate, occurs in "Der Wegweiser" ("The Signpost"), the twentieth song in the cycle. Like "Der Lindenbaum," this is a turning point of utmost importance and one made powerfully mysterious by Müller's choice of genre. *Die Winterreise* is a monodrama, a category distinct from dramatic monologues such as Robert Browning's "My Last Duchess" or

some of Müller's own *Griechenlieder*. In dramatic monologue, the word "monologue" notwithstanding, one can usually discern three distinct presences: the speaker of the poem, an implied listener or audience to whom the persona speaks, and the poet himself, his own world view and ethical judgments frequently apparent between the lines. Browning in fact trades masterfully in the ironic discrepancy between the speaker's view of himself and a larger judgment that the poet implies and that the reader must infer from hints in the poem. But in Müller's monodrama, the poet has deliberately excluded both the implied presence of an auditor and as much evidence of his own control as possible. Whatever we know, we know entirely from the wanderer's point of view, with no listeners from within the cycle to hear the wanderer's words and no trace of Müller's own gregarious personality. Throughout the winter journey, the wanderer talks to himself as if entirely alone, and there is no narrator to supply information the wanderer himself omits. In effect, we the readers and listeners become eavesdroppers who hear, at great length, things never intended to be heard. Of course, we know as we read that we are not actually spying unseen on private travail, since this is fiction, but Müller makes of this feint a considerable source of the poetry's power. He also pretends that the sequence of twenty-four poems is composed en route, not in the wake of past events, thoughts, and realizations, but in the present. As the wanderer knows or feels something, so do we, at that very moment.

Missing information is central to the depiction of inner life. After all, if the wanderer believes himself alone, why should he read aloud or explain what he can see all too clearly? The greatest unknown is the signpost at the crossroads in "Der Wegweiser." Here, the wanderer asks himself why his journey is so different from those of other people. It is not, he recognizes, a matter of chance that he takes hidden, difficult paths, snow-covered and harsh: he seeks them out, without knowing why. Signposts point the way to towns, but he will have nothing to do with other human beings, even though he is innocent of any wrongdoing. When he asks himself what "foolish longing" drives him out into the wilderness, the adjective "törichtes" (foolish, crazy) speaks volumes about his frustration and need to know what compulsion condemns him to exile. At that moment, he sees a signpost, a metaphorical road-within-the-mind, telling him his fate—but he does not say what it is. He states to himself only that aspect which most horrifies him: that no one can return. Most critics have read the signpost as a symbol of death, but what then is the meaning of "Das Wirtshaus," which follows right after, both in Müller's final ordering and in Schubert's? There, the wanderer's destined path ("mein Weg") brings him to a cemetery, where his longing for death is denied yet again. It seems far more likely that what

the wanderer sees at that fateful moment is a living death, one in which he is forever barred from the recipro-
cated love and domesticity for which he had longed, indeed, shut out of society altogether. Whether that
unbearable continued existence is the product of disease or some other circumstance hardly matters; indeed,
the moment gains in tragic force because neither Fate's sentence nor its cause is specified.

Schubert's setting of "Der Wegweiser" is a bridge back to the very beginning of the cycle.
Throughout "Gute Nacht," we hear groupings of four non-legato repeated pitches or chords as the principal
accompanimental figure, suggesting stylized abstractions of footsteps and underscoring the idea of the journey.
Much later, we hear the figure again throughout "Der Wegweiser," when the wanderer demands to know why his
journey is so difficult, so unlike other people's paths in life. Only in these two lieder does the journey itself
engage his entire awareness and the journeying figure dominate the song. Elsewhere, it appears sporadically, its
signification especially powerful in the few, economical appearances in the second half of the cycle. For exam-
ple, at the end of "Die Krähe," we hear a single instance of the repeated non-legato pitches in the piano, telling
us wordlessly that the journey must go on. Just before the wanderer wearily sings, "O unbarmherz'ge Schenke,
doch weisest du mich ab?" (Oh cruel inn, are you turning me away?) in "Das Wirtshaus," we hear the journey-
ing figure in the piano—once again, the only occurrence in the song. The final appearance of the journeying
figure occurs in the twenty-third song, "Die Nebensonnen" ("The Phantom Suns"). Ice crystals refracted
through sunshine on rare occasions create "mock suns" on either side of the real sun, and the wanderer sees in
them a symbol of his sweetheart's eyes: illusory because she was never meant for him. When he laments, "Ach,
meine Sonnen seid ihr nicht!" (Alas, you are not my suns!), the journeying figure appears for the last time in
the accompaniment, elided with the last word of the phrase, "nicht" (not), as if to extend and underscore the
negation. One notes that the figure is subtle, abstract (it is not a melody), and infinitely mutable in its trans-
positions, harmonizations, and changing contexts, but perhaps that is only appropriate to the thing symbol-
ized. Every journey is different, and every moment of every journey is different.

Müller had a knack for concluding cycles with his finest efforts; even those who found little good
to say about his poetry had to admit that "Der Leiermann" ("The Hurdy-Gurdy Player") was an inspired end-
ing. The kinship between the wanderer and the elderly hurdy-gurdy player is obvious: Both are outcasts, poor
and alone; their music, such as it is, is ignored by other human beings. Even the dogs are hostile to them. The

elderly beggar is the wanderer's doppelgänger, the self divided, the image of what he will become. The hurdy-gurdy, with its ceaseless turning, is the instrument of obsession and the symbol of artistry now devoid of all meaning. The music is always the same, and the beggar's cup is always empty: simple symbols—but effective—for life as emptiness and futile repetition. "Der Leiermann" tragically epitomizes a human reality: Finding an audience has much to do with how one keeps going, in life and art, even when the only audience possible is a projection of nightmare fears about the future.

Schubert's setting of this last song in the winter journey is, in its utmost economy of means, as radical as this composer's foreshadowings of Wagnerian chromaticism in other songs. "Der Leiermann" is completely diatonic, the grace-notes in measures 1–2 the only touches of chromaticism. (This mimics what happens when a player begins to turn the wooden wheel that operates the drone strings, the sound at first slightly under the pitch and then becoming constant when the motion of the wheel is regular.) Schubert restricts this song essentially to a single harmony, nothing else. While unmistakably moored to A minor, this music does not exist to define a tonality, and such musical parameters as diatonicism, chromaticism, harmonic functions, and the like are ghosts of their classical selves. The "cadences," for example, are inflections that merely feign endings in a context of endless turning and ceaseless repetition. Even the last chord seems like a blind or bar, shutting us out from implied continuation beyond the fermata in the final bar. This music is what the wanderer fears his future will be—sounding nothingness—and it has the horrifying potential to go on and on and on, beyond bearing.

As noted earlier, Schubert was confronting his own probable fate when he set this cycle to music, especially in the bleak picture at the close—not a true ending, one notices. Syphilis, the AIDS of the nineteenth century, often took an unpredictable span of time to exact its final toll in dementia and paralysis before death brought release. Schubert perhaps saw the dread workings of this disease in its last stages when he was hospitalized in 1823 for its virulent onset, and he would have known what awaited him if accidental death or some other illness did not intervene first. Would he too become the hurdy-gurdy player of Müller's imagination, his seemingly inexhaustible treasury of music reduced to one harmony and a single skeletal phrase droned over and over, frozen in place? Would this hollow simulacrum of music be all that was left to him? At the end, the wanderer turns to the elderly beggar and asks two questions, posed, as the pianist Graham

Johnson observes, with the exquisite courtesy of the dispossessed: "Wunderlicher Alter, soll ich mit dir geh'n? Willst zu meinen Liedern deine Leier dreh'n?" (Strange old man, shall I go with you? Will you grind your organ to my songs?) "Je est un autre" ("I" is an Other), the great nineteenth-century French poet Arthur Rimbaud wrote, and the tension of the moment when Self speaks to Self in such grim colloquy is evident in the metrical disjunctions between the voice and the piano at this place. I like to think that Death, perhaps flattered by Schubert's many and varied portrayals of him in music, spared the composer at the end the fate he so dreaded, taking him swiftly, before syphilis could wreak its worst on him. Despite our sorrow at his early death (and we will always wonder what might have been), we can only be grateful that Schubert did not become the wanderer but instead turned him into "songs I like better than the rest."

—*Susan Youens*

Schubert's Winterreise

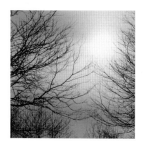 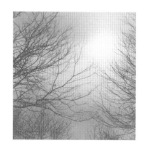 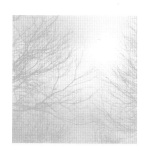

I. Good Night—*Gute Nacht*

I came as a stranger; as a stranger now I leave.

Fremd bin ich eingezogen, fremd zieh' ich wieder aus,

✦

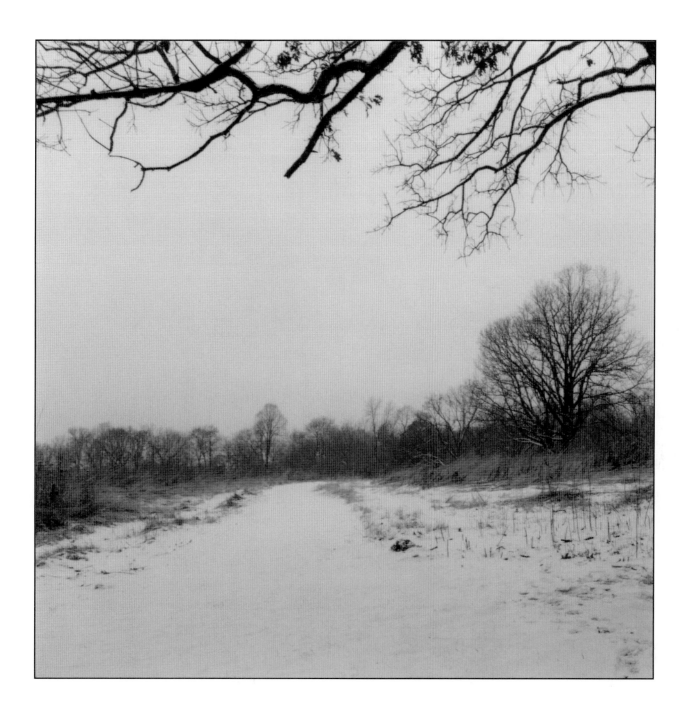

Gute Nacht

The flowers of May once welcomed me warmly;

der Mai war mir gewogen mit manchem Blumenstrauß.

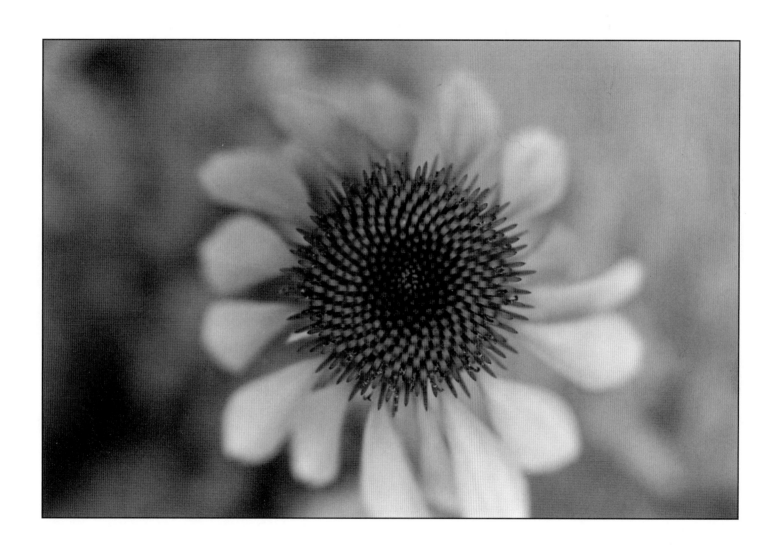

Gute Nacht

a young girl spoke of love, her mother even of marriage.

Das Mädchen sprach von Liebe, die Mutter gar von Eh';

>-I+>-O-<+I-<

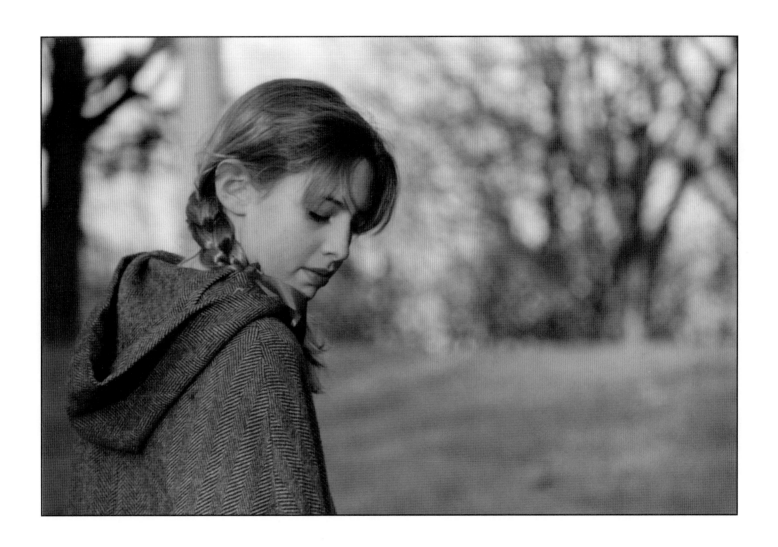

Gute Nacht

Good Night

Now all is bleak—the pathway covered with snow.

The time of departure is not mine to choose; I must find my way alone in this darkness. With the shadow of the moon at my side, I search for traces of wildlife in the white snow.

nun ist die Welt so trübe, der Weg gehüllt in Schnee.

Ich kann zu meiner Reisen nicht wählen mit der Zeit,
muß selbst den Weg mir weisen in dieser Dunkelheit.
Es zieht ein Mondenschatten als mein Gefährte mit,
und auf den weißen Matten such' ich des Wildes Tritt.

>─┤◆├─○─┤◆├─<

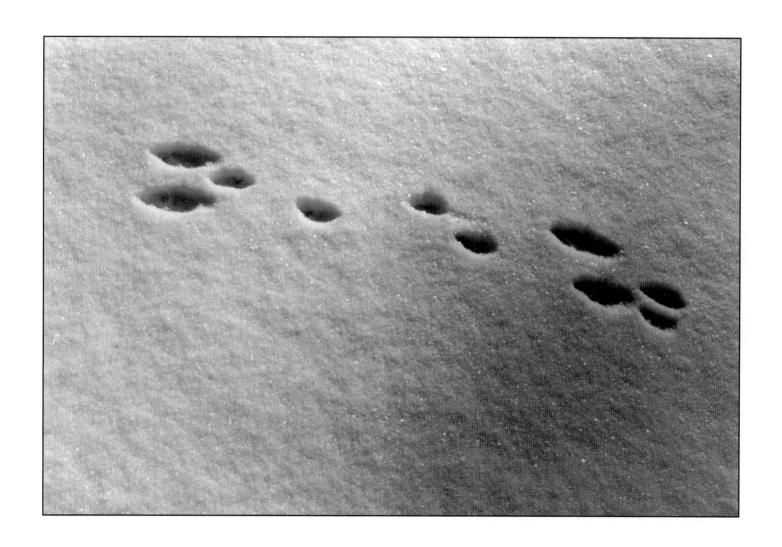

Gute Nacht

Why should I linger and give them reason to send me away? Let stray hounds howl outside their master's house. Love likes to wander from one to another, as if God willed it so.

My darling, farewell.

Was soll ich länger weilen, daß man mich trieb hinaus?
Laß irre Hunde heulen vor ihres Herren Haus.
Die Liebe liebt das Wandern —Gott hat sie so gemacht—
von Einem zu dem Andern, Fein Liebchen, gute Nacht.

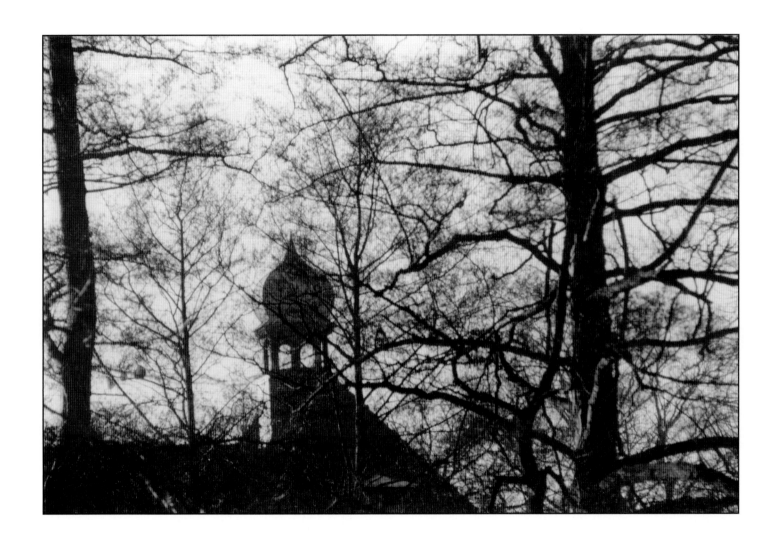

Gute Nacht

A quiet step, a careful shutting of the door so your sleep is not disturbed,

Will dich im Traum nicht stören, wär Schad' um deine Ruh,
sollst meinen Tritt nicht hören, sacht, sacht, die Türe zu!

⊱╌◆╌○╌◆╌⊰

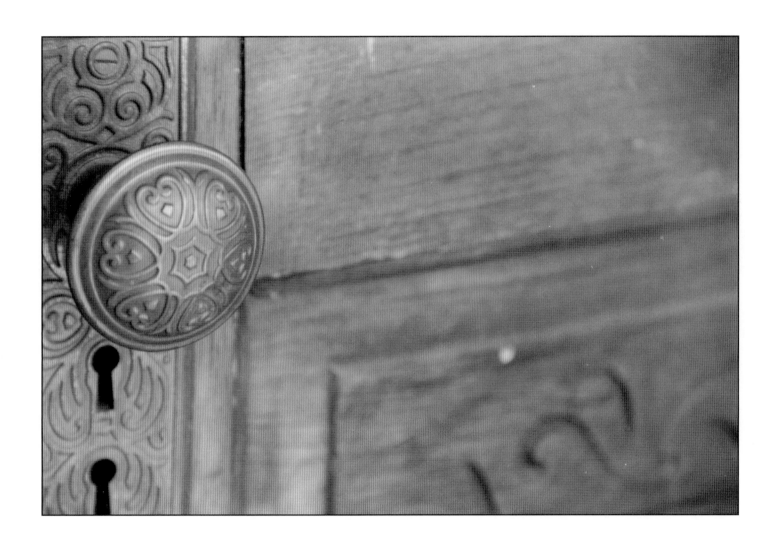

Gute Nacht

and two words written on the gate as I leave,
"Good night," to let you know I thought of you.

Schreib' im Vorübergehen ans Tor dir: gute Nacht,
damit du mögest sehen, an dich hab' ich gedacht.

⊱—◆—○—◆—⊰

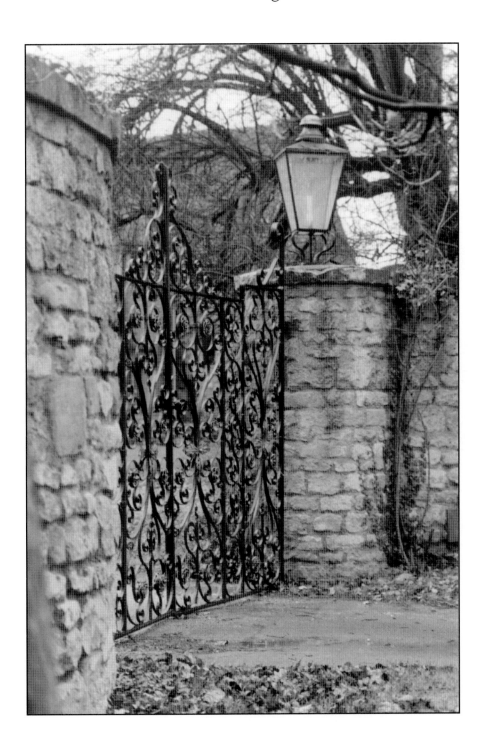

Gute Nacht

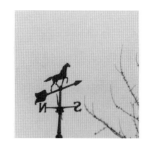 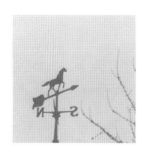

II. The Weather Vane—*Die Wetterfahne*

On the roof of my sweetheart's house the wind toys playfully with the weather vane.

Der Wind spielt mit der Wetterfahne auf meines schönen Liebchens Haus.

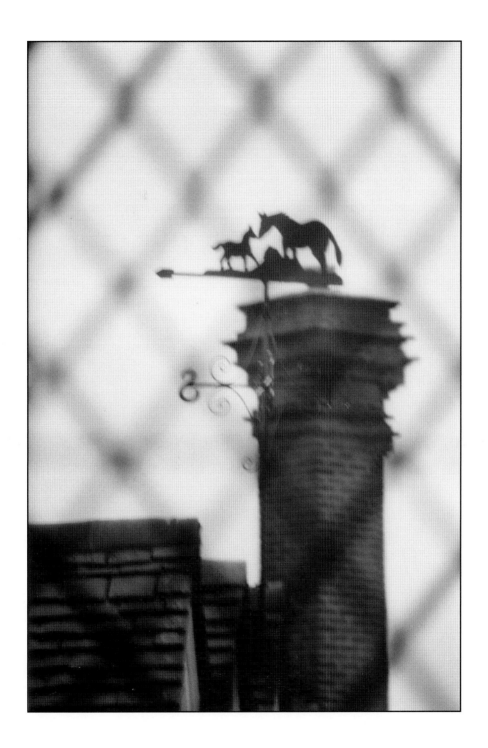

Die Wetterfahne

In my half-crazed mind I imagined that it was ridiculing this poor outcast. Had he noticed the symbol on the roof of the house, he would never have sought a true love within.

Da dacht' ich schon in meinem Wahne, sie pfiff' den armen Flüchtling aus.

Er hätt' es eher bemerken sollen, des Hauses aufgestecktes Schild,
so hätt' er nimmer suchen wollen im Haus ein treues Frauenbild.

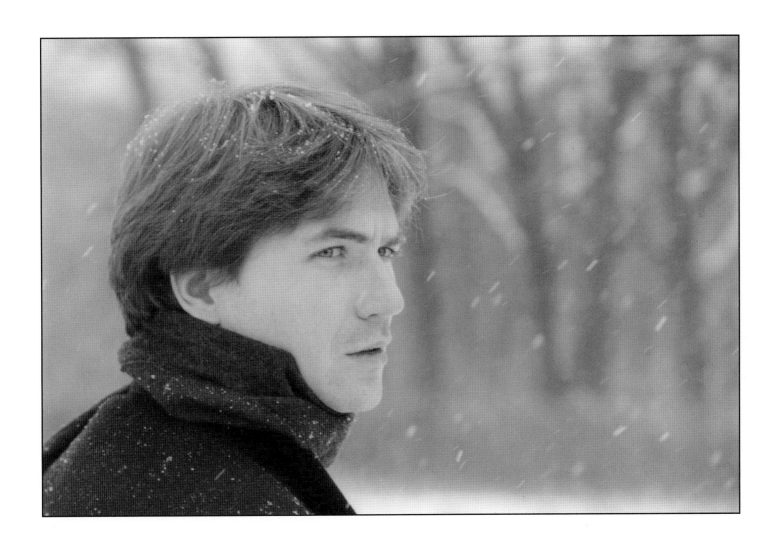

Die Wetterfahne

Inside the house the wind plays more furtively with hearts.

Der Wind spielt drinnen mit den Herzen wie auf dem Dach, nur nicht so laut.

>—•—<

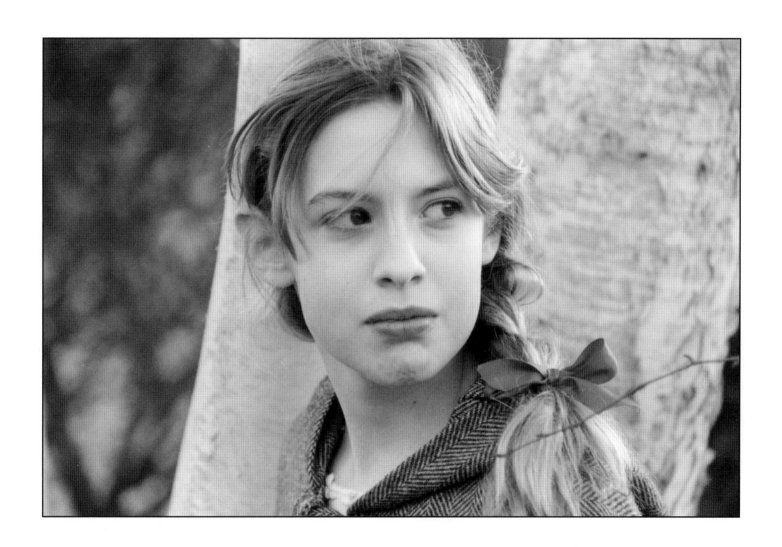

Die Wetterfahne

What do they care about my pain? Their child is
a rich bride.

Was fragen sie nach meinen Schmerzen? Ihr Kind ist eine reiche Braut.

⋗–┼⬧⭢–○–⭠⬧┼–⋖

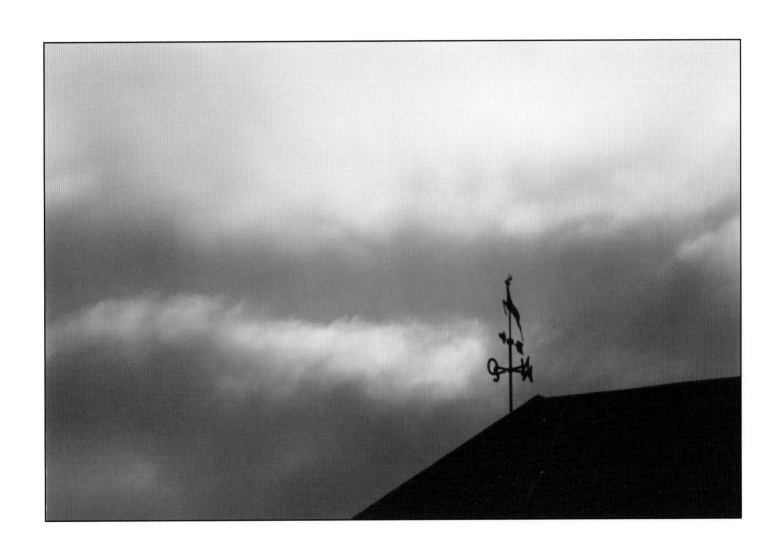

Die Wetterfahne

 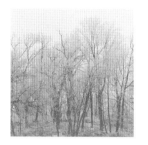

III. Frozen Tears—*Gefror'ne Tränen*

Frozen tears fall from my cheeks. How could I not have noticed that I was weeping?

Gefror'ne Tropfen fallen von meinen Wangen ab:
ob es mir denn entgangen, daß ich geweinet hab'?

⊰┄◈┄◯┄◈┄⊱

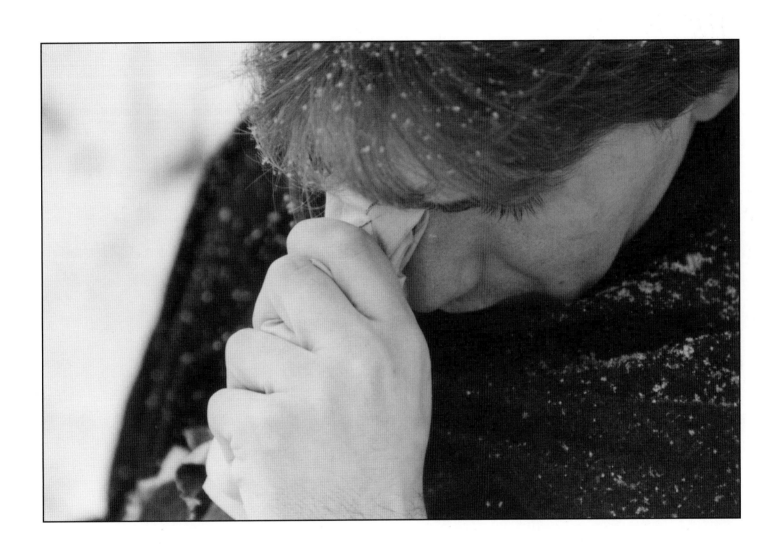

Gefror'ne Tränen

Oh tears, are you so tepid that you stiffen with ice like the chilled morning dew?

Ei Tränen, meine Tränen, und seid ihr gar so lau,
daß ihr erstarrt zu Eise, wie kühler Morgentau?

⊱—⊶⊙⊷—⊰

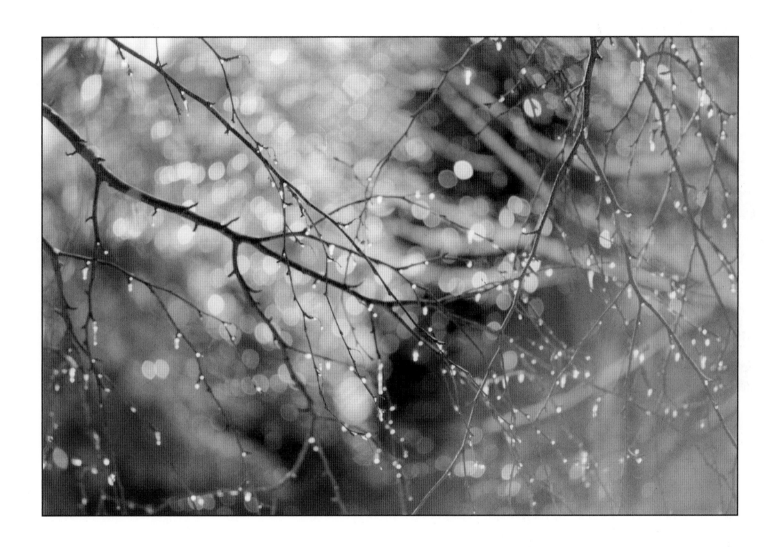

Gefror'ne Tränen

And yet you well up from the depths of my being so
glowing hot, as if you were intent on melting all the ice of winter!

Und dringt doch aus der Quelle der Brust so glühend heiß,
als wolltet ihr zerschmelzen des ganzen Winters Eis!

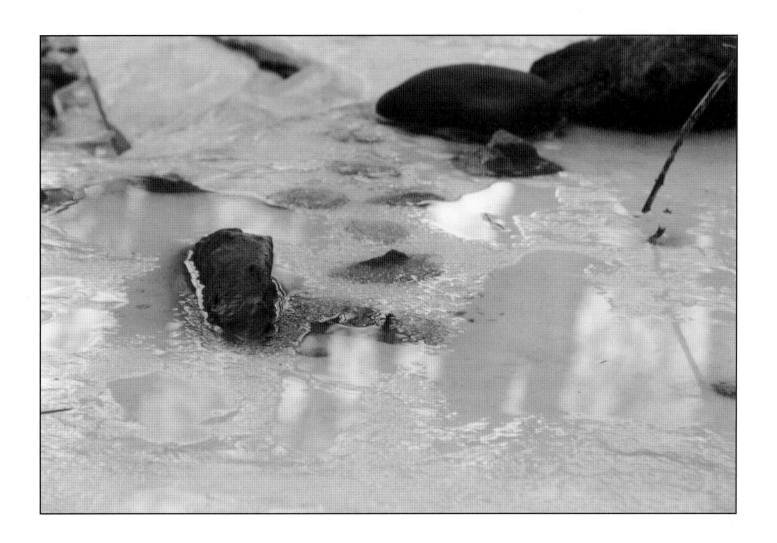

Gefror'ne Tränen

IV. Numbness—*Erstarrung*

Vainly I search for a trace of her step in the snow-covered meadow, where we strolled arm in arm. I want to kiss the ground, to bore through the ice and snow with my hot tears until I see the earth beneath.

Ich such' im Schnee vergebens nach ihrer Tritte Spur,
wo sie an meinem Arme durchstrich die grüne Flur.

Ich will den Boden küssen, durchdringen Eis und Schnee
mit meinen heißen Tränen, bis ich die Erde seh'.

>―◄►―○―◄►―◄

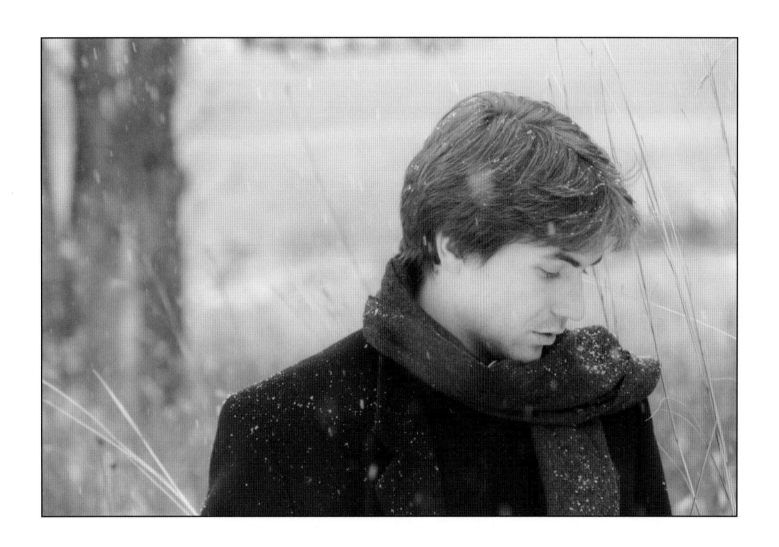

Erstarrung

Where can I find a flower, or even a single blade of grass?

Wo find' ich eine Blüte? Wo find' ich grünes Gras?

>—◆—○—◆—<

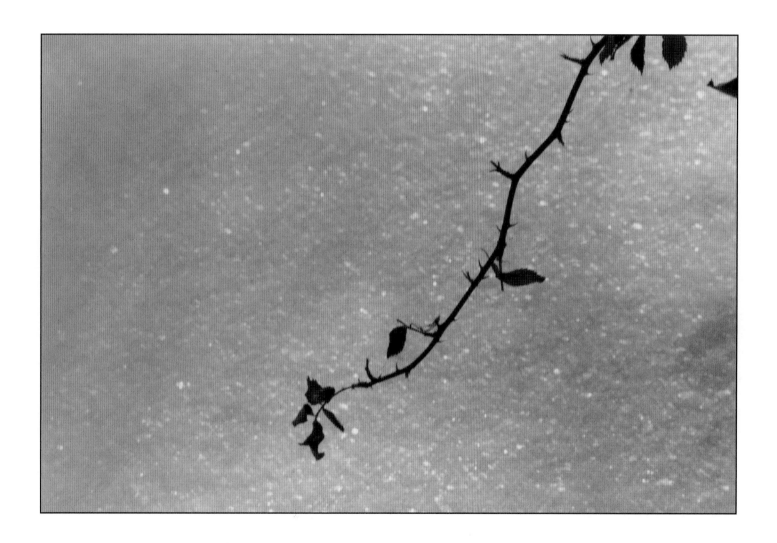

Erstarrung

All is gone, the land pale and lifeless.

Die Blumen sind erstorben, der Rasen sieht so blaß.

><•>•O•<•><

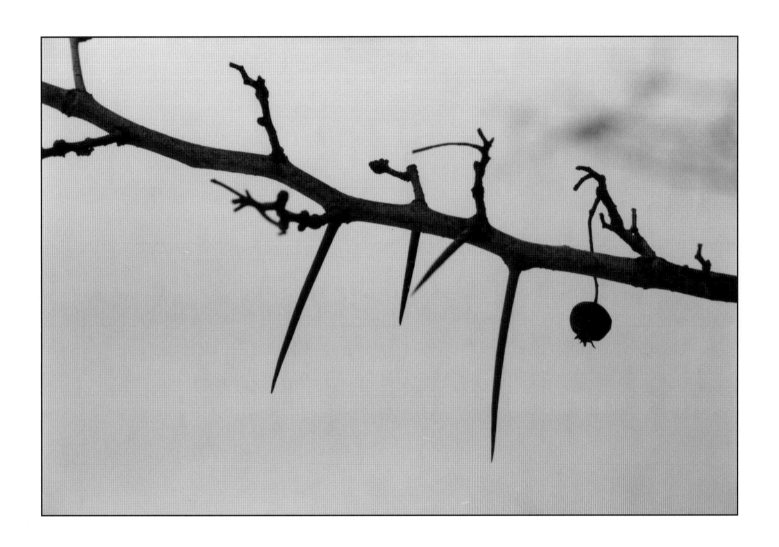

Erstarrung

Is there no remembrance to take from here, nothing to bring me comfort? When my anguish subsides, who will speak to me of her?

Soll denn kein Angedenken ich nehmen mit von hier?
Wenn meine Schmerzen schweigen, wer sagt mir dann von ihr?

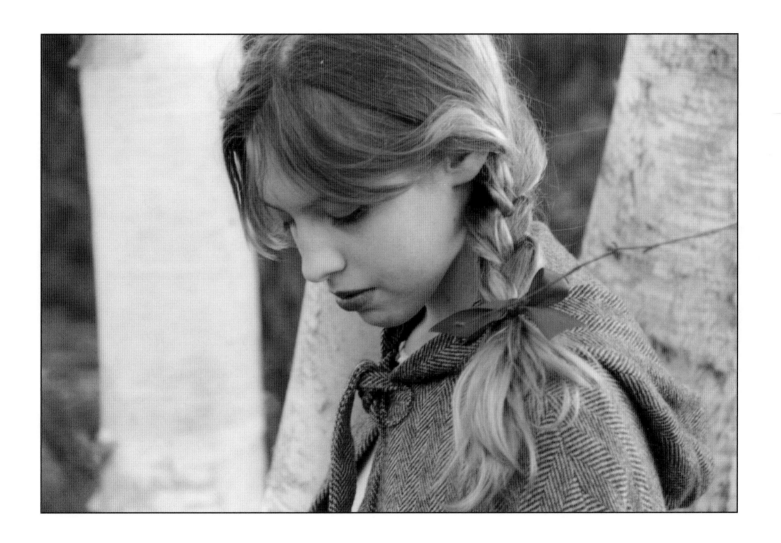

Erstarrung

Her image stares coldly from my chilled heart. Should my heart ever soften, her image will dissolve and disappear.

Mein Herz ist wie erstorben, kalt starrt ihr Bild darin,
schmilzt je das Herz mir wieder, fließt auch ihr Bild dahin!

⊰⊱

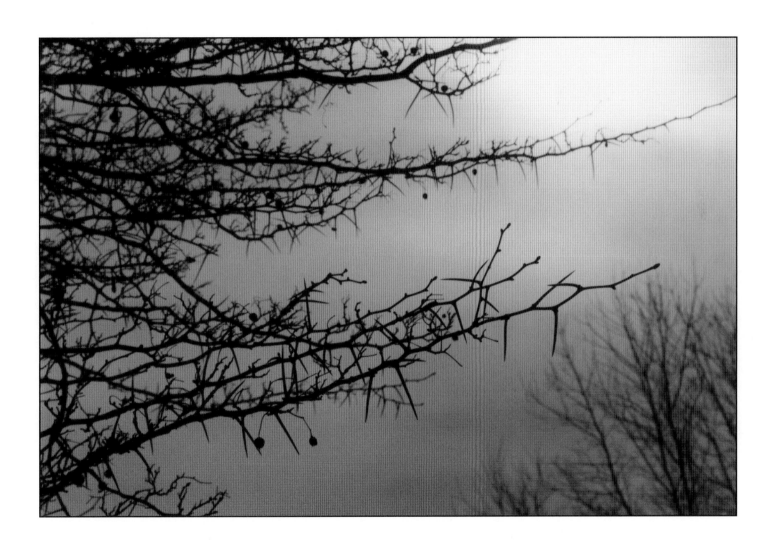

Erstarrung

V. The Linden Tree—*Der Lindenbaum*

A linden tree grows by the well at the gate.

Am Brunnen vor dem Tore da steht ein Lindenbaum;

>─◦─◦─◦─◦─<

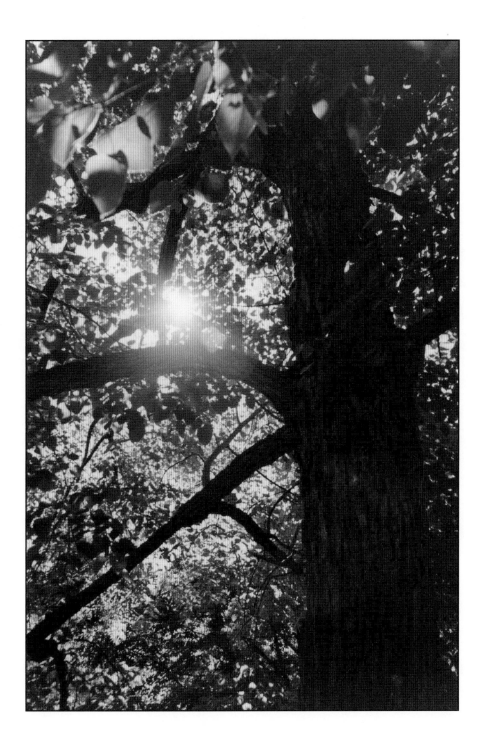

Der Lindenbaum

In its leafy shade my beautiful fantasies took flight.
I carved loving words in its bark; it drew me close in joy
and sorrow.

Ich traümt' in seinem Schatten so manchen süßen Traum.

Ich schnitt in seine Rinde so manches liebe Wort;
es zog in Freud' und Leide zu ihm mich immer fort.

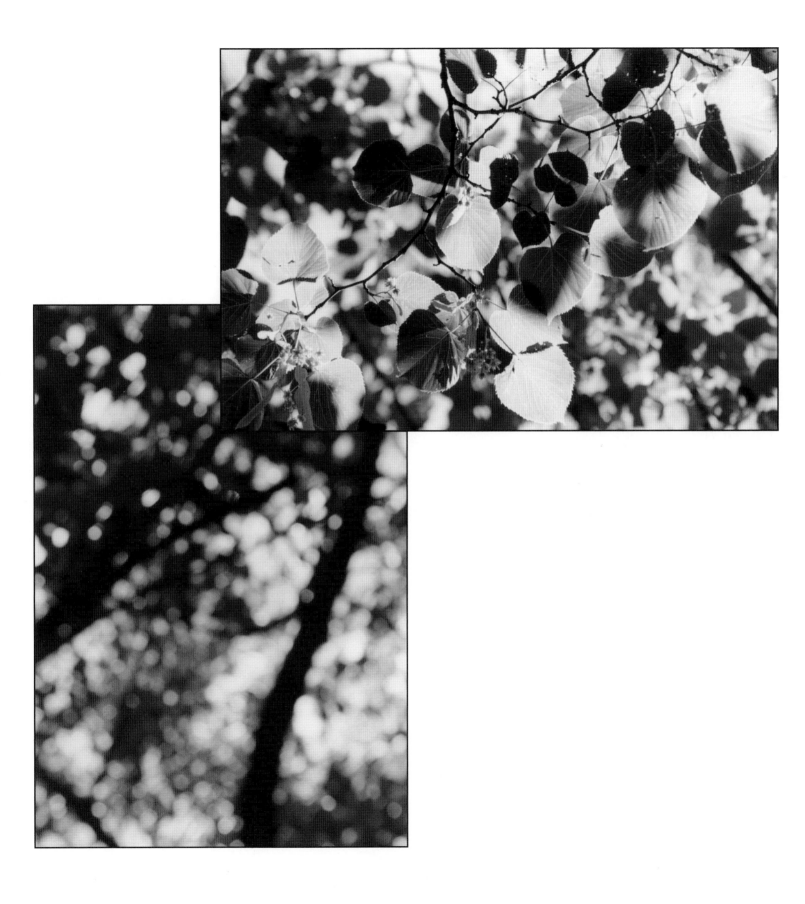

Now I must walk past it in the dead of night, ignoring it with eyes shut tight even in darkness.

Ich mußt' auch heute wandern vorbei in tiefer Nacht,
da hab' ich noch im Dunkeln die Augen zugemacht.

>─┼◆─○─◆┼─<

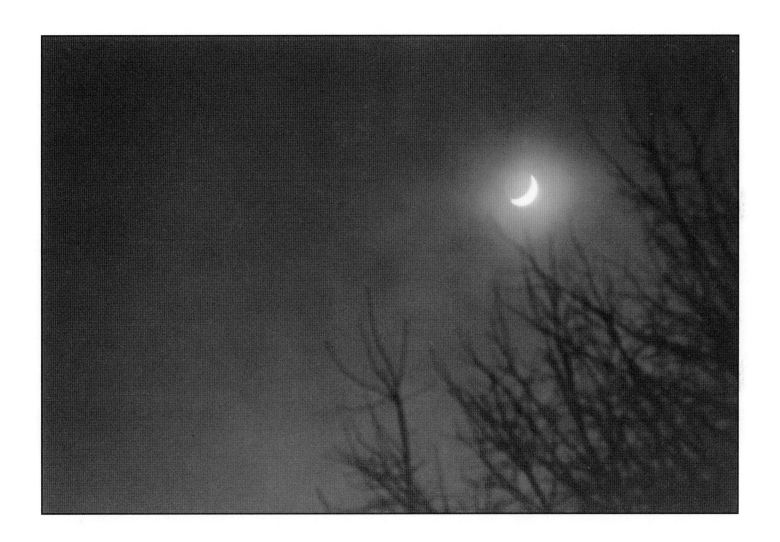

Der Lindenbaum

And its branches rustle as if calling to me: "Come here, dear friend; you'll find repose with me."

The cold wind was sharp against my face and blew the hat from my head, but I did not turn back.

Und seine Zweige rauschten, als riefen sie mir zu:
komm her zu mir, Geselle, hier find'st du deine Ruh'!

Die kalten Winde bliesen mir grad' ins Angesicht,
der Hut flog mir vom Kopfe, ich wendete mich nicht.

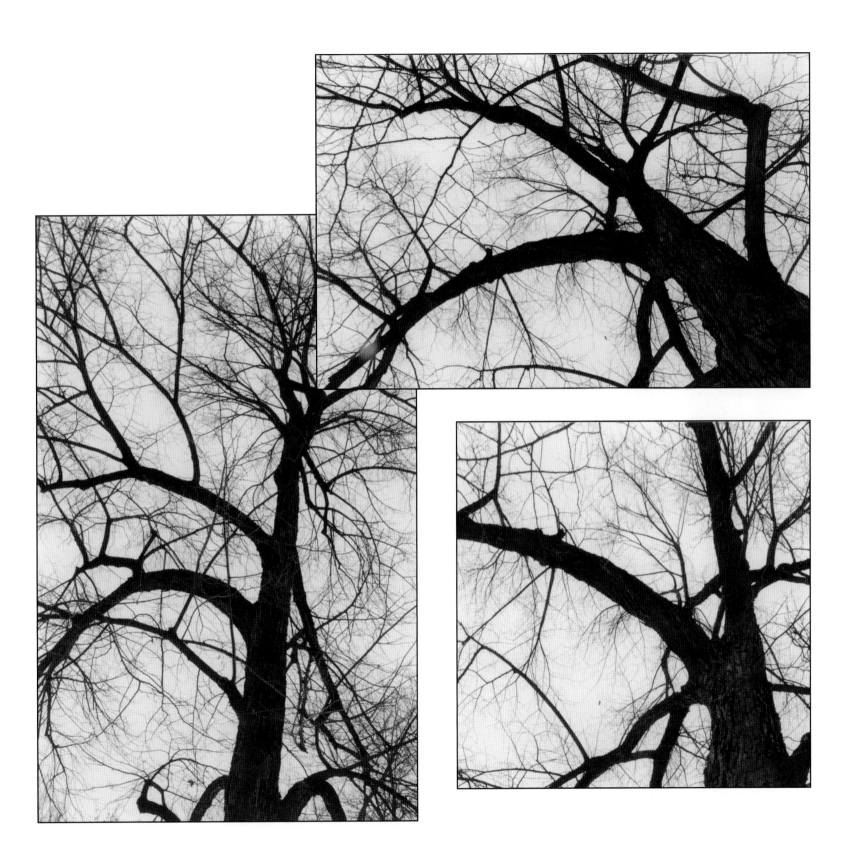

Now, far down the road, the rustling in my ear persists:
"You would have found repose there."

Nun bin ich manche Stunde entfernt von jenem Ort,
und immer hör' ich's rauschen: du fändest Ruhe dort!

>―┼―♦―○―◄―┼―◄

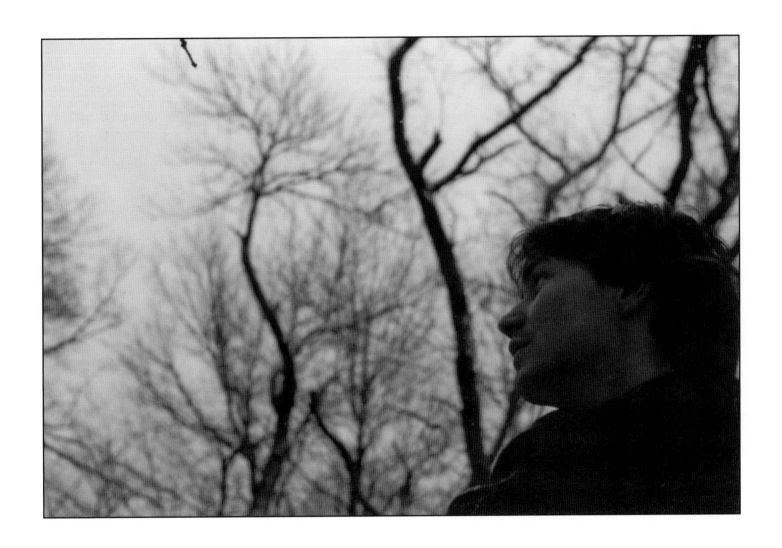

Der Lindenbaum

VI. Floodwaters—*Wasserflut*

Streams of tears have fallen from my eyes into the snow.
The cold flakes greedily swallow up my hot misery.

Manche Trän' aus meinen Augen ist gefallen in den Schnee;
seine kalten Flocken saugen durstig ein das heiße Weh.

><+>–O–<+><

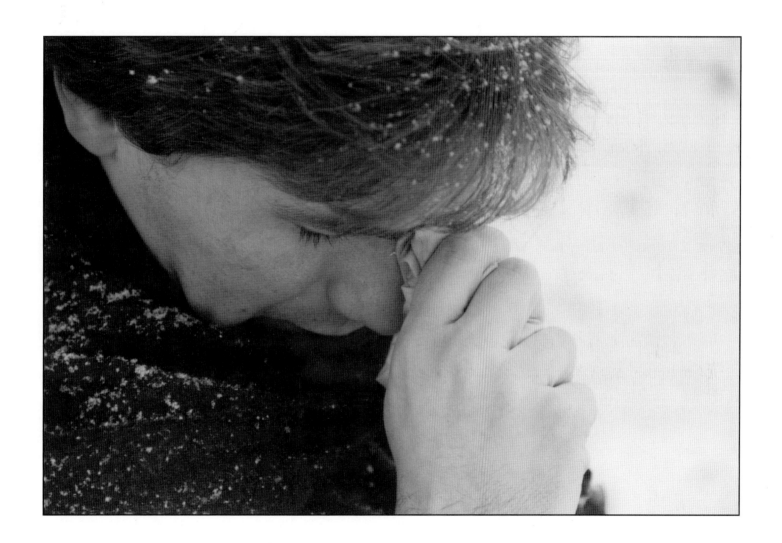

Wasserflut

When the grass is ready to sprout, a balmy breeze will waft
over the ice; the ice will splinter into shards, and the soft snow
will melt.

Wenn die Gräser sprossen wollen, weht daher ein lauer Wind,
und das Eis zerspringt in Schollen, und der weiche Schnee zerrinnt.

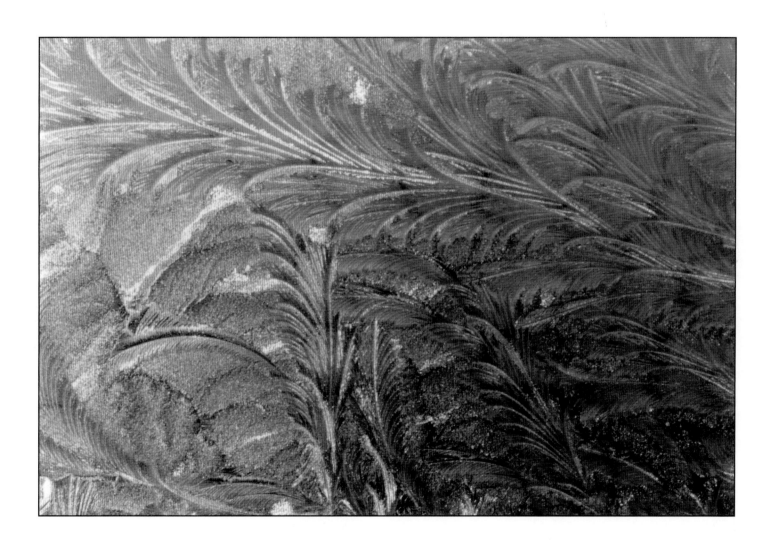

Wasserflut

Snow, you know so well my longing. What course will you now take?

Schnee, du weißt von meinem Sehnen, sag', wohin doch geht dein Lauf?

<div align="center">⤐ ⬥ ⬥ ○ ⬥ ⬥ ⤏</div>

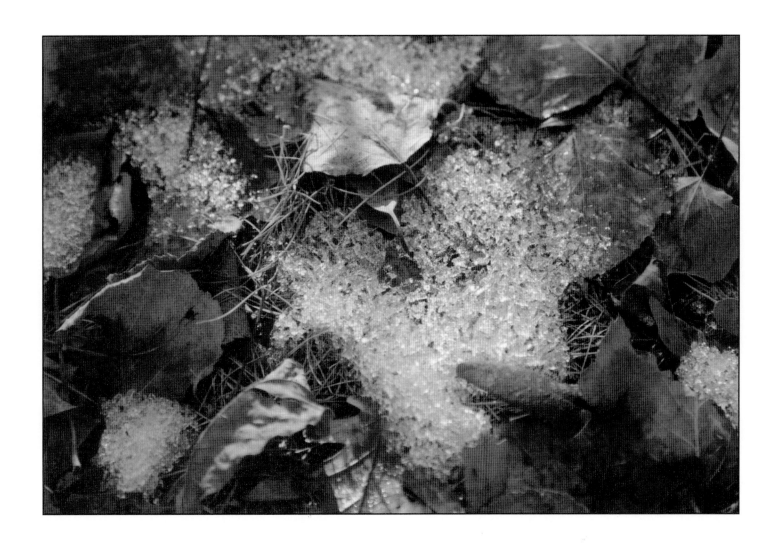

Wasserflut

My tears will lead you to the brook that flows down
through the town. As you pass through its cheerful byways,
keep watch.

Folge nach nur meinen Tränen, nimmt dich bald das Bächlein auf.

Wirst mit ihm die Stadt durchziehen, muntre Straßen ein und aus,

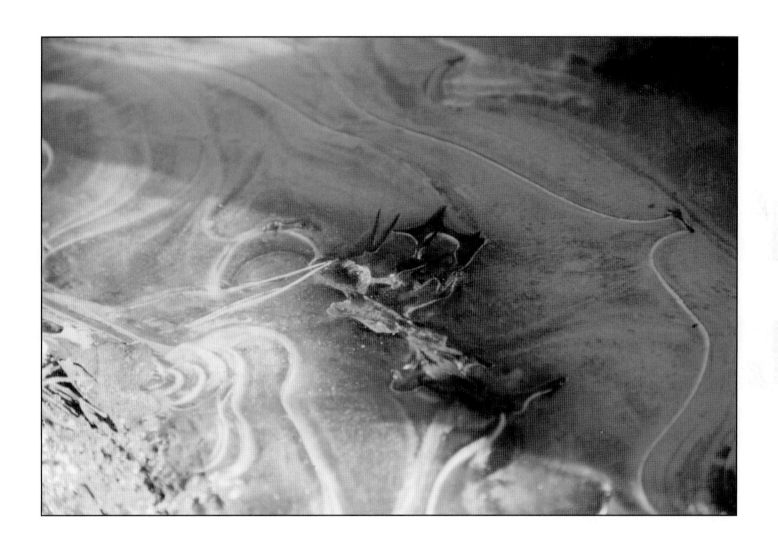

Wasserflut

Where you feel my tears begin to burn will be my sweetheart's house.

fühlst du meine Tränen glühen, da ist meiner Liebsten Haus.

>—O—<

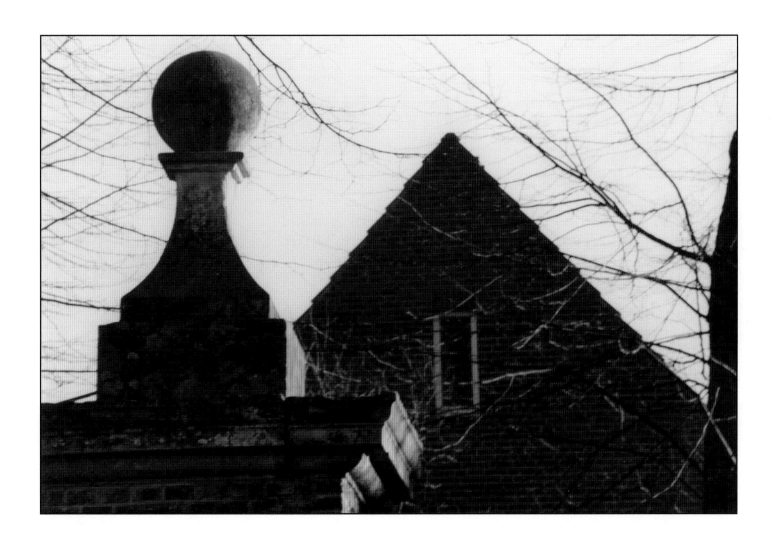

Wasserflut

VII. By the Stream—*Auf dem Flusse*

Dear stream that once roared along, wild and sparkling clear, you are now so still and quiet, with no parting word for me.

Der du so lustig rauschtest, du heller, wilder Fluß,
wie still bist du geworden, gibst keinen Scheidegruß!

>⊷⊶⊷◦⊷⊶⊷<

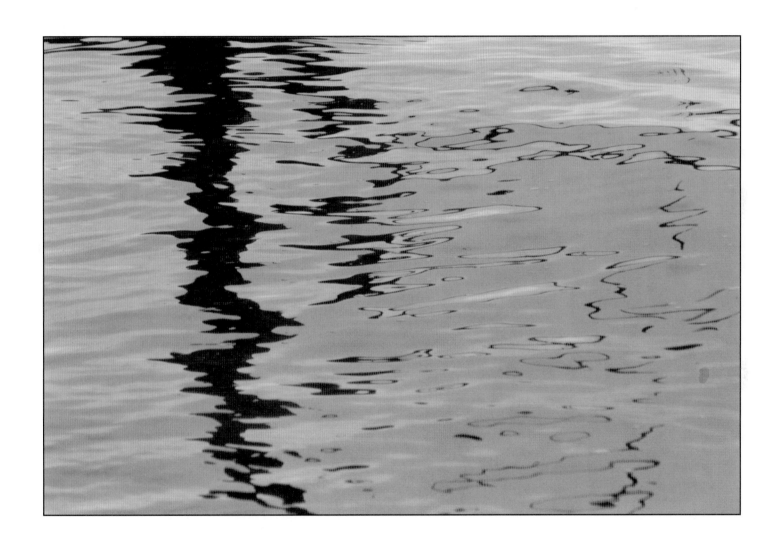

Auf dem Flusse

You've covered yourself with a stiff, hard crust and lie cold and unmoving, sprawled in the sand.

Mit harter, starrer Rinde hast du dich überdeckt,
liegst kalt und unbeweglich im Sande ausgestreckt.

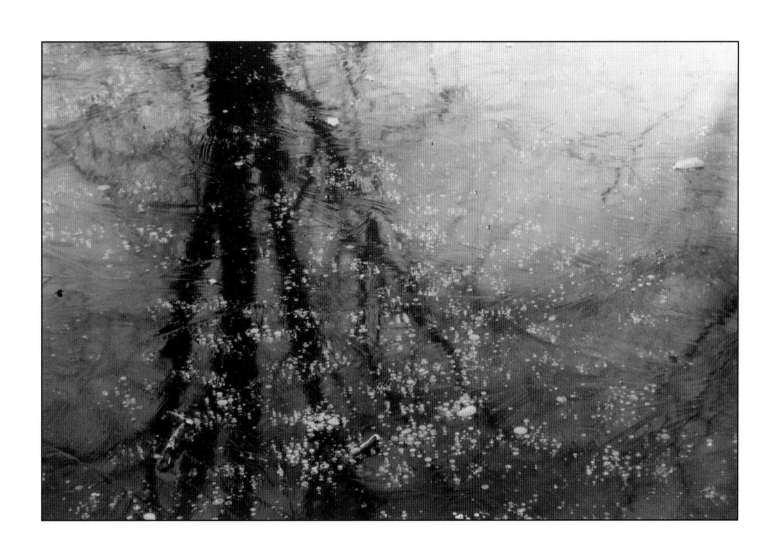

Auf dem Flusse

By the Stream

In your frozen armor I carve with a sharp stone my
sweetheart's name, the time and day: the day that we met,

In deine Decke grab' ich mit einem spitzen Stein
den Namen meiner Liebsten und Stund' und Tag hinein:

Den Tag des ersten Grußes,

⤝⬩⬦⬩○⬩⬦⬩⬤

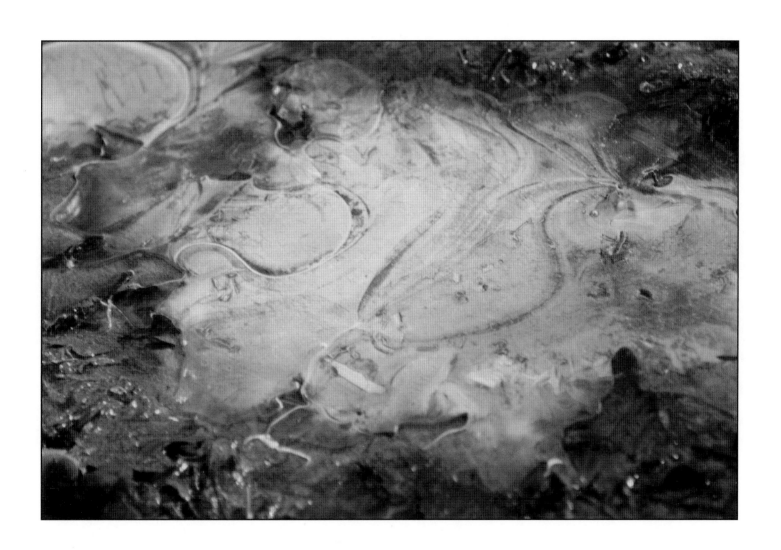

Auf dem Flusse

and the day that I left. Encircling the name and numbers is a broken ring.

den Tag, an dem ich ging; um Nam' und Zahlen windet sich ein zerbroch'ner Ring.

⊱┈◈┈◯┈◈┈⊰

Auf dem Flusse

My heart, do you recognize yourself in this brook?

Mein Herz, in diesem Bache erkennst du nun dein Bild?

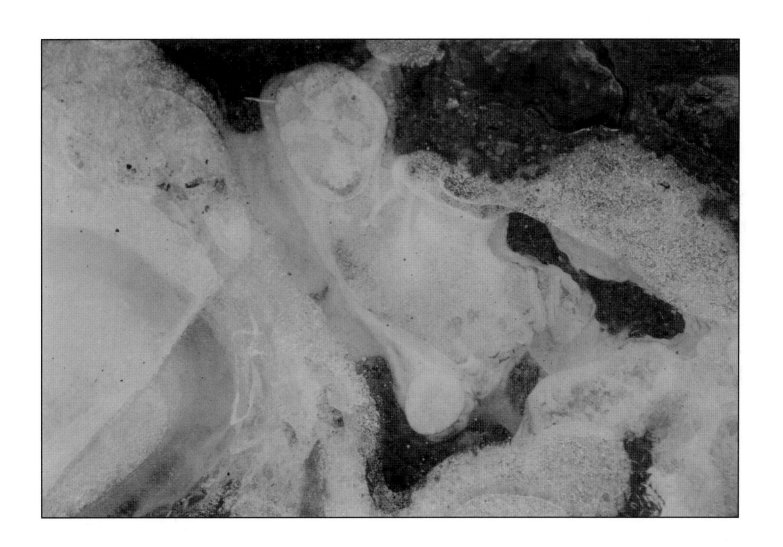

Auf dem Flusse

Are the waters beneath its surface as turbulent as yours?

Ob's unter seiner Rinde wohl auch so reißend schwillt?

⊱—⊰•⊙•⊱—⊰

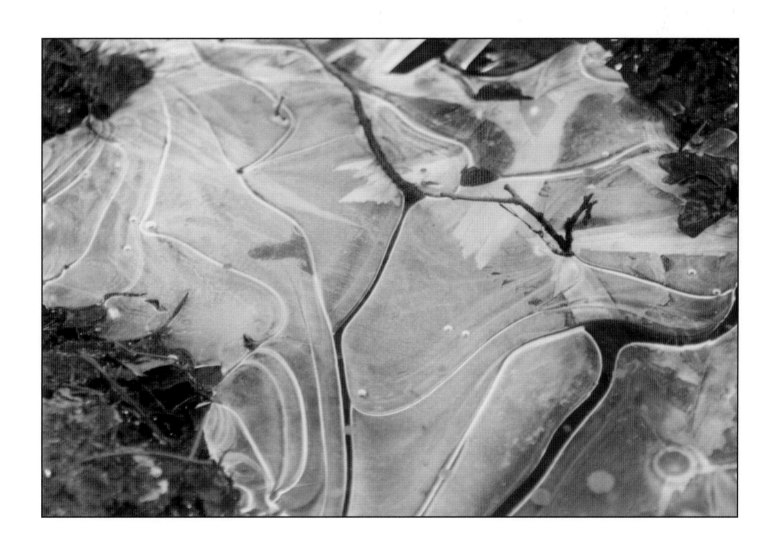

Auf dem Flusse

VIII. Backward Glance—*Rückblick*

The fiery soles of my feet burn with every step, even though ice and snow cover the pathway.

Es brennt mir unter beiden Sohlen, tret' ich auch schon auf Eis und Schnee,

>―◦―◦―◦―◦―‹

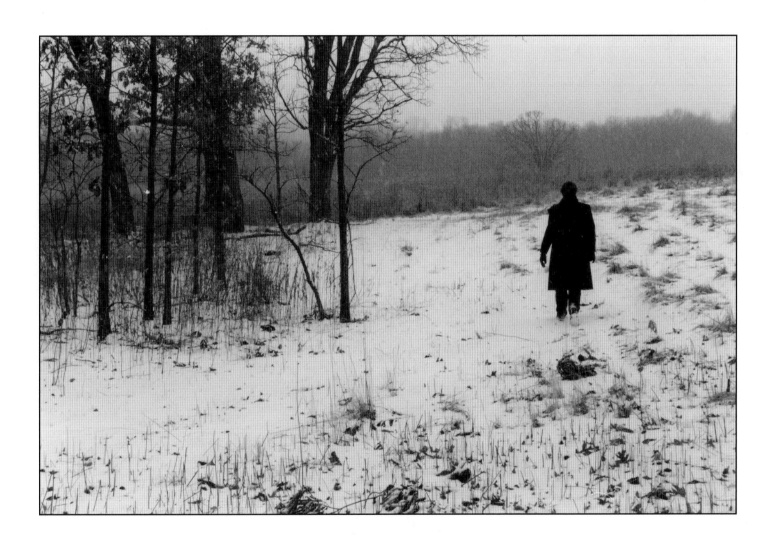

Rückblick

There will be no stopping for breath until the towers of the town are out of sight. In my haste to leave I stumbled over every cobblestone;

Ich möcht' nicht wieder Atem holen, bis ich nicht mehr die Türme seh'.

Hab' mich an jedem Stein gestoßen, so eilt' ich zu der Stadt hinaus;

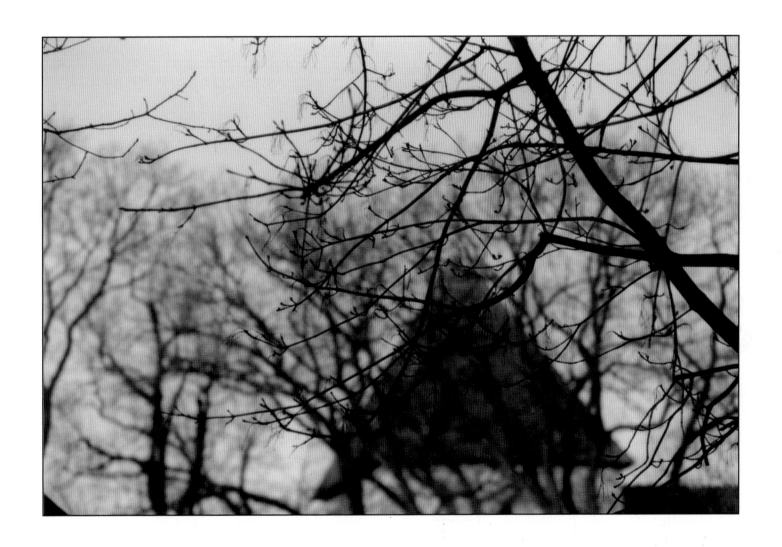

Rückblick

the crows pelted my head with clumps of snow and ice
from the rooftops.

die Krähen warfen Bäll' und Schloßen auf meinen Hut von jedem Haus.

⊱┄◈┄○┄◈┄⊰

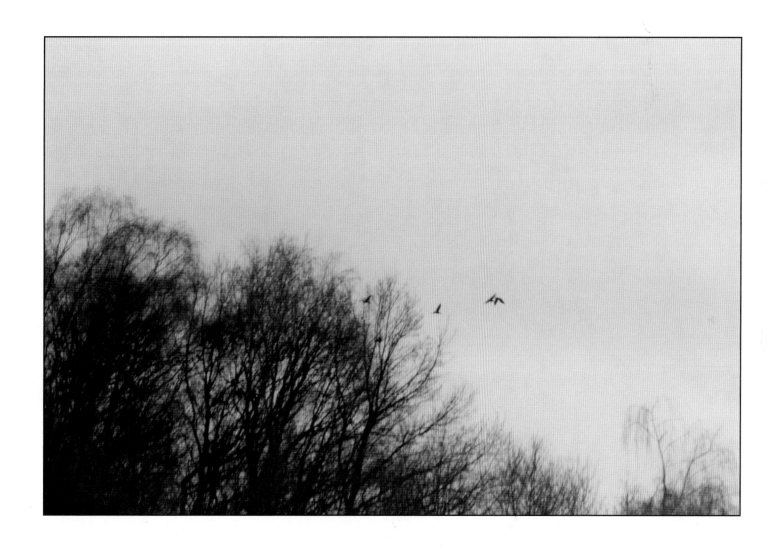

Rückblick

How different was my reception when I arrived, you fickle town! The warbling larks and nightingales outdid each other on the gleaming windowsills; the robust linden trees were bursting with blooms;

Wie anders hast du mich empfangen, du Stadt der Unbeständigkeit!
An deinen blanken Fenstern sangen die Lerch' und Nachtigall im Streit.

Die runden Lindenbäume blühten,

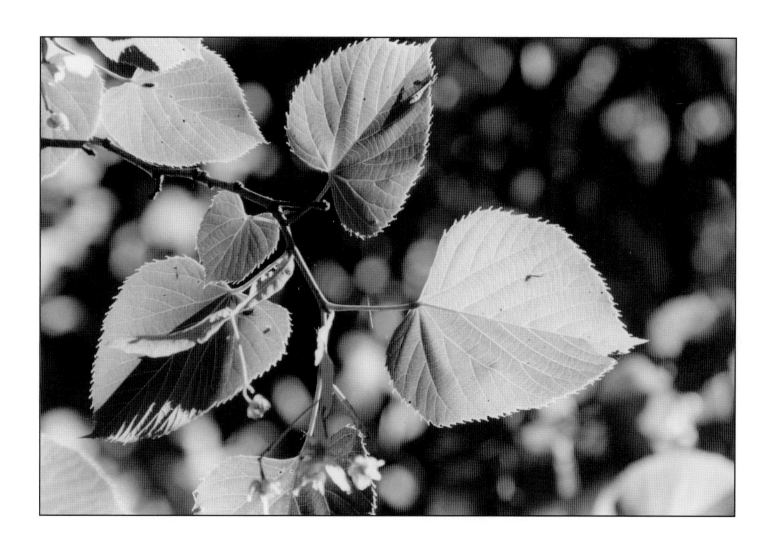

Rückblick

the clear brooklet babbled cheerfully; and oh,
the bewitching gleam in the young girl's eyes! That was your
undoing, my friend!

die klaren Rinnen rauschten hell, und ach, zwei Mädchenaugen glühten!
Da war's gescheh'n um dich, Gesell!

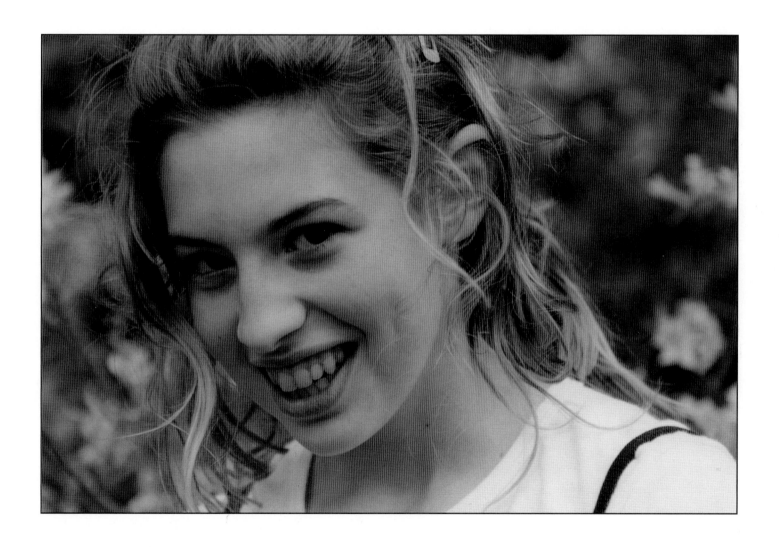

Rückblick

Thinking back on that day I long to glance behind me one more time, yes, even stagger back and stand quietly before her house.

Kömmt mir der Tag in die Gedanken, möcht' ich noch einmal rückwärts seh'n,
möcht' ich zurücke wieder wanken, vor ihrem Hause stille steh'n.

>+<>+O+<>+<

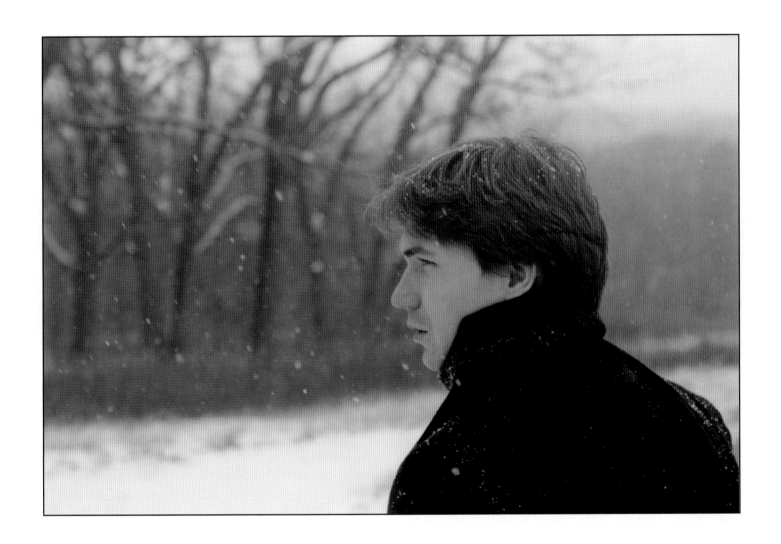

Rückblick

IX. Will-o'-the-Wisp—*Irrlicht*

I have been lured deep into the rocky gorges by a will-o'-the-wisp. Finding a way out does not concern me.

In die tiefsten Felsengründe lockte mich ein Irrlicht hin.
Wie ich einen Ausgang finde liegt nicht schwer mir in dem Sinn.

>⊱━◆━○━◆━⊰

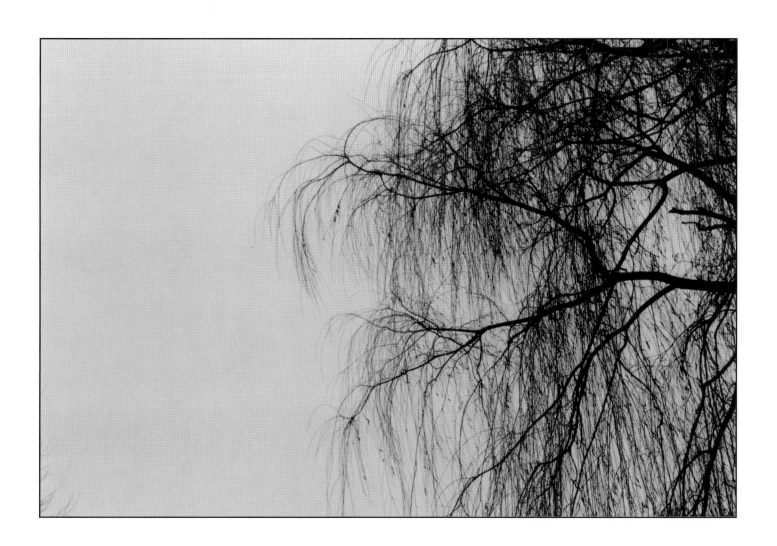

Irrlicht

I'm accustomed to going astray, and every path
has a destination.

Bin gewohnt das Irregehen, 's führt ja jeder Weg zum Ziel:

>─┤◆├─○─┤◆├─<

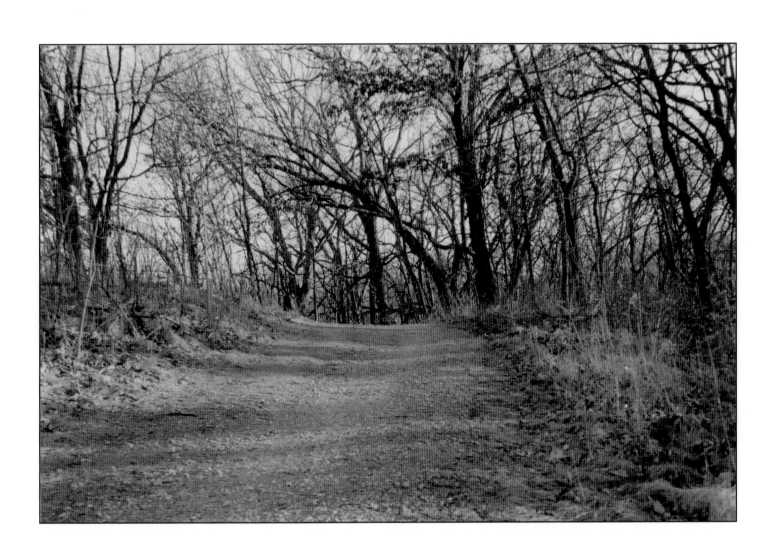

Irrlicht

Our joys, our sorrows are all a game of the
will-o'-the-wisp.

Unsre Freuden, unsre Leiden, alles eines Irrlichts Spiel!

>-|◄►-○-◄►-|<

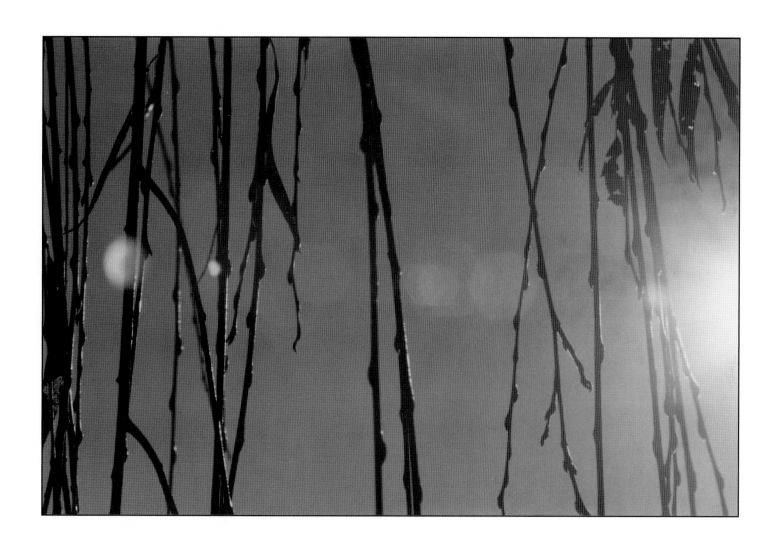

Irrlicht

Calmly I wend my way down through the dry bed of the mountain creek.

Durch des Bergstroms trock'ne Rinnen wind' ich ruhig mich hinab,

>—◆—○—◆—<

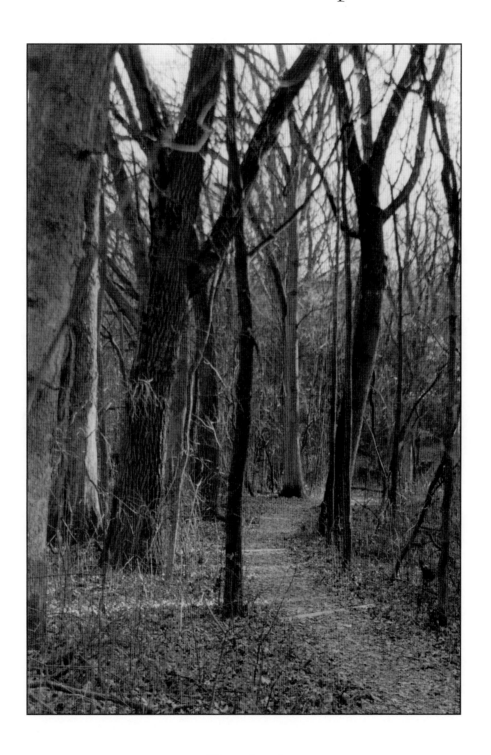

Irrlicht

Every stream eventually arrives at the sea, every suffering at its grave.

jeder Strom wird's Meer gewinnen, jedes Leiden auch sein Grab.

⊰—⟡—◦—⟡—⊱

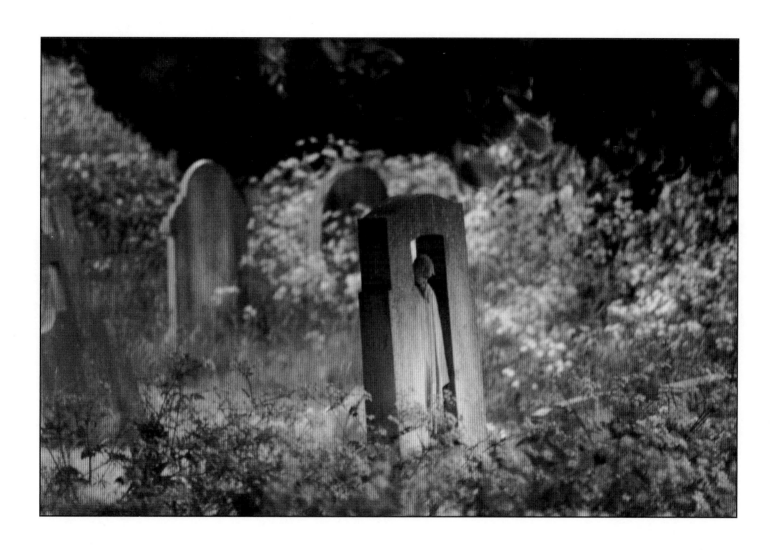

Irrlicht

 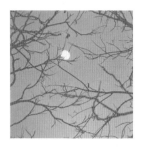 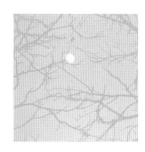

X. Rest—*Rast*

Now at last I begin to realize how tired I am.
It is time to rest.

Nun merk' ich erst, wie müd' ich bin, da ich zur Ruh' mich lege;

>⊢•⊶○⊷•⊣≺

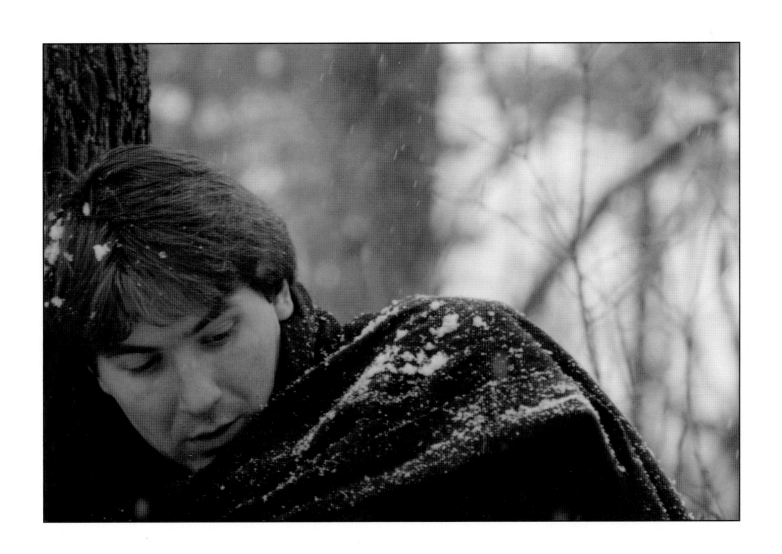

Rast

Traveling the open road buoyed my spirits. My feet did not beg for mercy—it was too cold to stop; my back felt no burden, and the force of the gale pushed me onward.

das Wandern hielt mich munter hin auf unwirtbarem Wege.

Die Füße frugen nicht nach Rast, es war zu kalt zum Stehen;
der Rücken fühlte keine Last, der Sturm half fort mich wehen.

⊱────◦────⊰

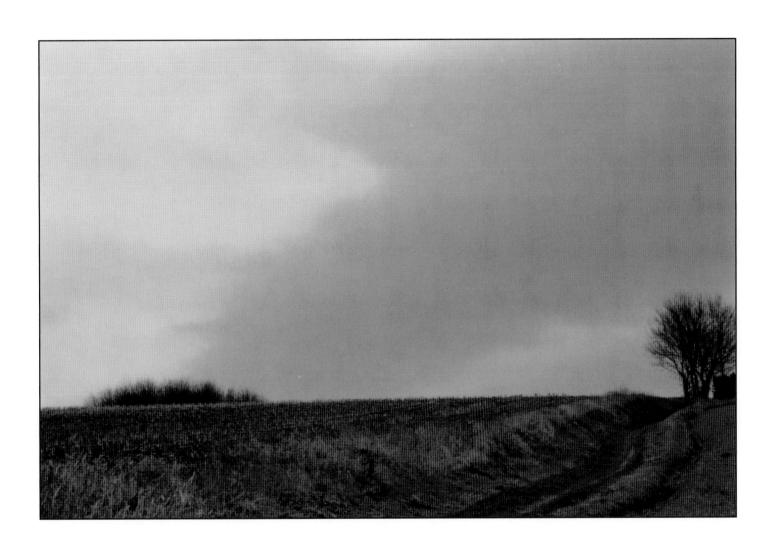

Rast

Here in a charcoal-maker's hut I've found shelter, yet my limbs are burning from their wounds and cannot relax.

In eines Köhlers engem Haus hab' Obdach ich gefunden;
doch meine Glieder ruh'n nicht aus, so brennen ihre Wunden.

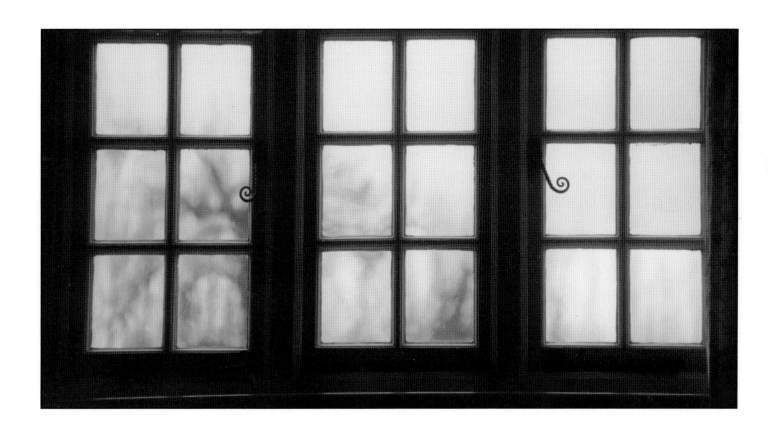

Rast

Even you, courageous heart, so daring in the midst
of battle and storm, feel for the first time in the stillness the
sharp sting of the serpent as it stirs.

Auch du, mein Herz, in Kampf und Sturm so wild und so verwegen,

fühlst in der Still' erst deinen Wurm mit heißem Stich sich regen!

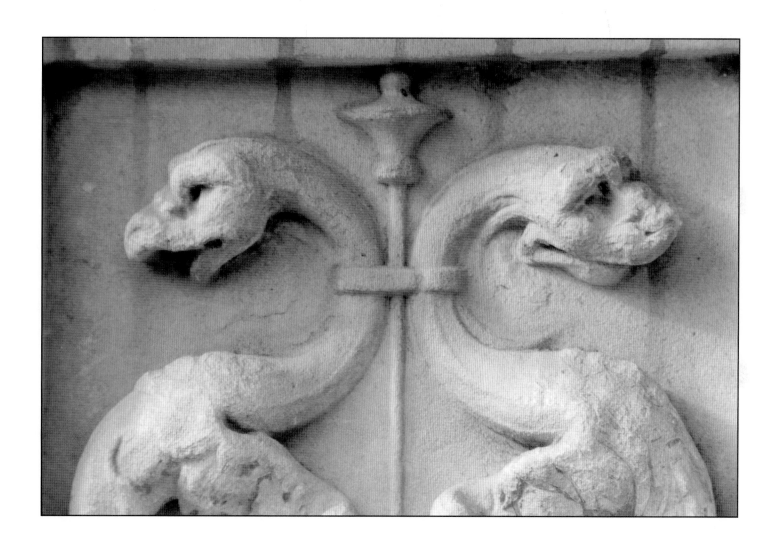

Rast

XI. Dreams of Spring—*Frühlingstraum*

I was dreaming of beautiful flowers—flowers the color of May—and of lovely green meadows filled with bird song.

Ich träumte von bunten Blumen, so wie sie wohl blühen im Mai;
Ich träumte von grünen Wiesen, von lustigem Vogelgeschrei.

⊱─◆─○─◆─⊰

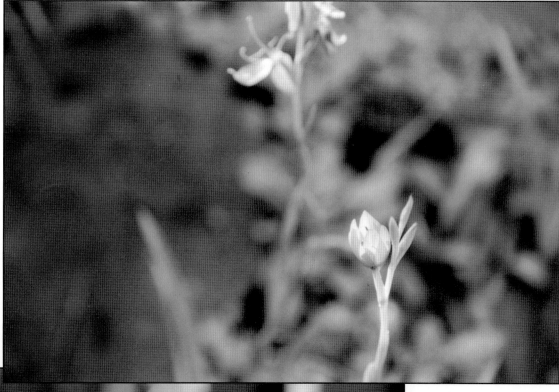

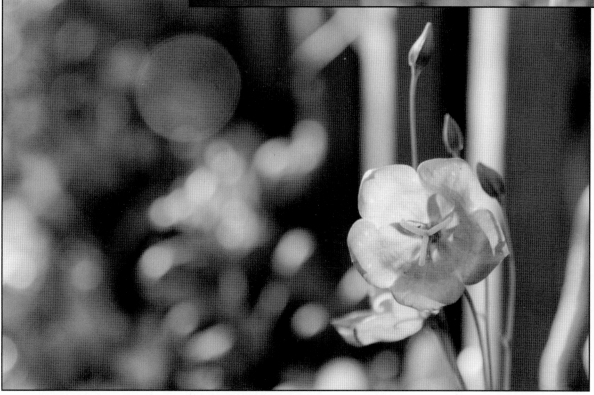

The crowing of the cock awakened me. It was dark and cold, and the ravens were screeching from the roof.

Und als die Hähne krähten, da ward mein Auge wach;

da war es kalt und finster, es schrieen die Raben vom Dach.

>―◄►―○―◄►―◄

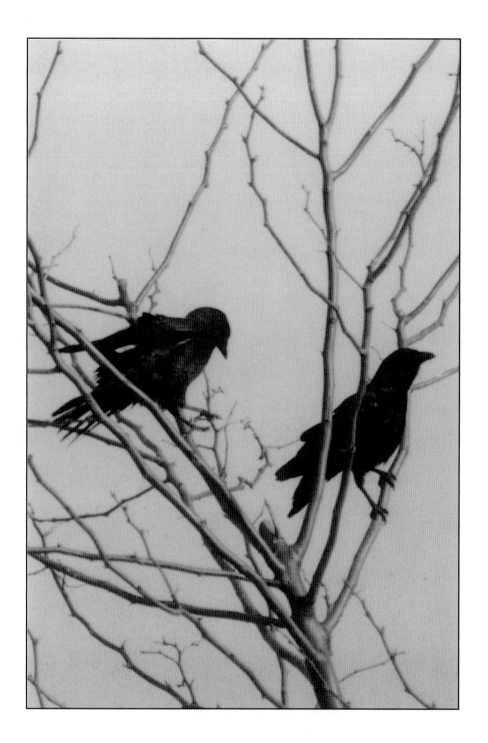

Frühlingstraum

Look! Who has painted leaves on the windowpane, as if to mock the dreamer who sees flowers in winter?

Doch an den Fensterscheiben, wer malte die Blätter da?
Ihr lacht wohl über den Träumer, der Blumen im Winter sah.

⊱━◈━○━◈━⊰

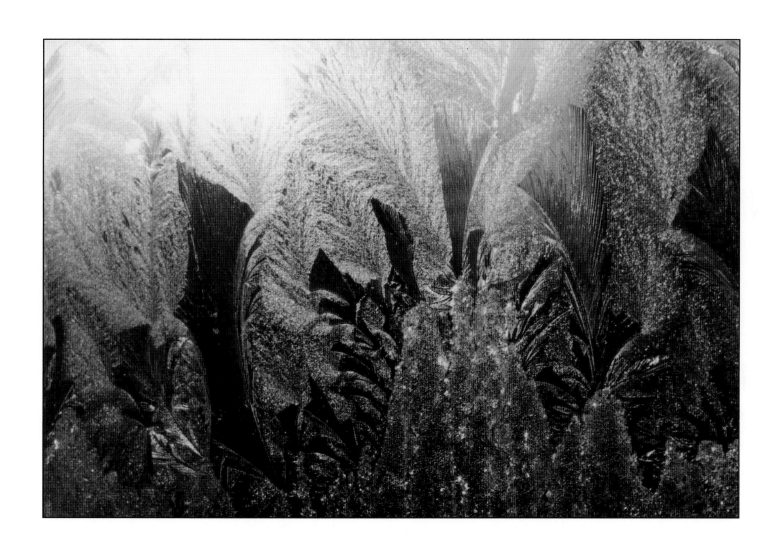

Frühlingstraum

Yes, I dreamed of love, and of being loved by a beautiful young girl, of caressing and kissing, of happiness and bliss. At cockcrow my heart woke up. Now I sit here alone, thinking back on my dream.

Ich träumte von Lieb' um Liebe, von einer schönen Maid,
von Herzen und von Küssen, von Wonne und Seligkeit.

Und als die Hähne krähten, da ward mein Herze wach,
nun sitz' ich hier alleine und denke dem Traume nach.

>⊷⊙⊶≺

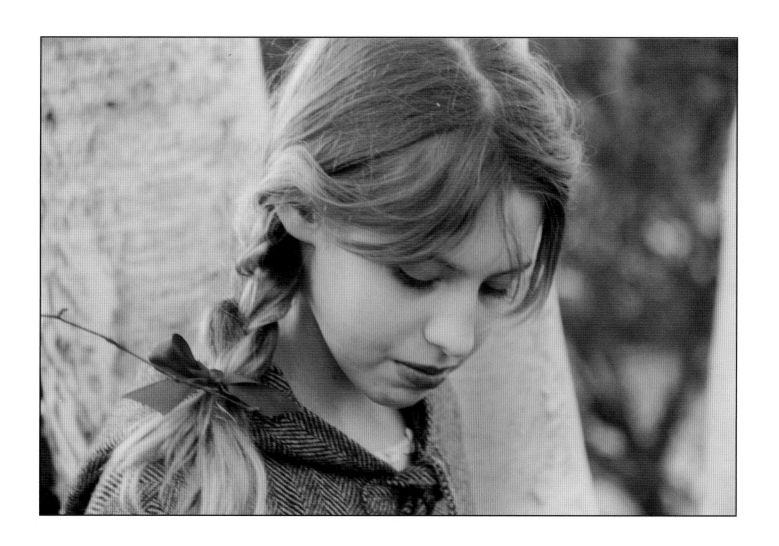

Frühlingstraum

My eyes close; my heart beats warmly again. When will the leaves on the windowpane turn green? When will I hold my sweetheart in my arms?

Die Augen schließ' ich wieder, noch schlägt das Herz so warm. Wann grünt ihr Blätter am Fenster? Wann halt' ich mein Liebchen im Arm?

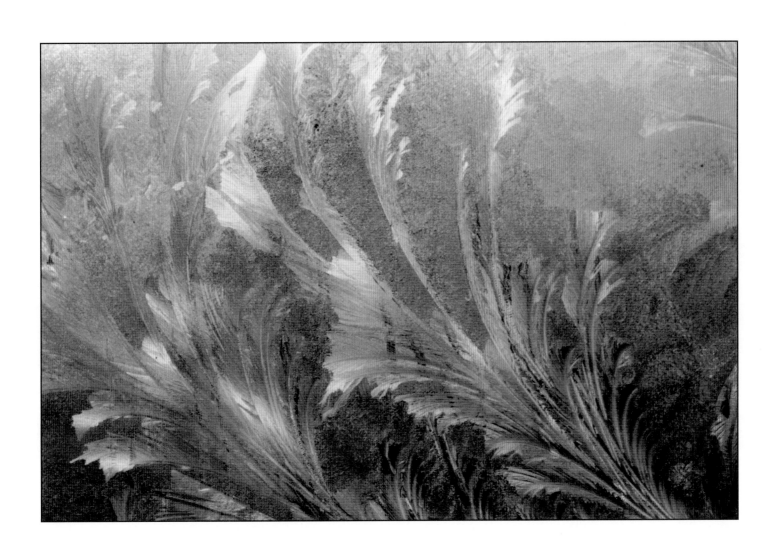

Frühlingstraum

 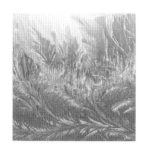

XII. Loneliness——*Einsamkeit*

Like a dark cloud drifting across a clear sky as a tired gust of wind ruffles the pine tops,

Wie eine trübe Wolke durch heit're Lüfte geht,
wenn in der Tanne Wipfel ein mattes Lüftchen weht,

>—I‹›—O—‹I‹

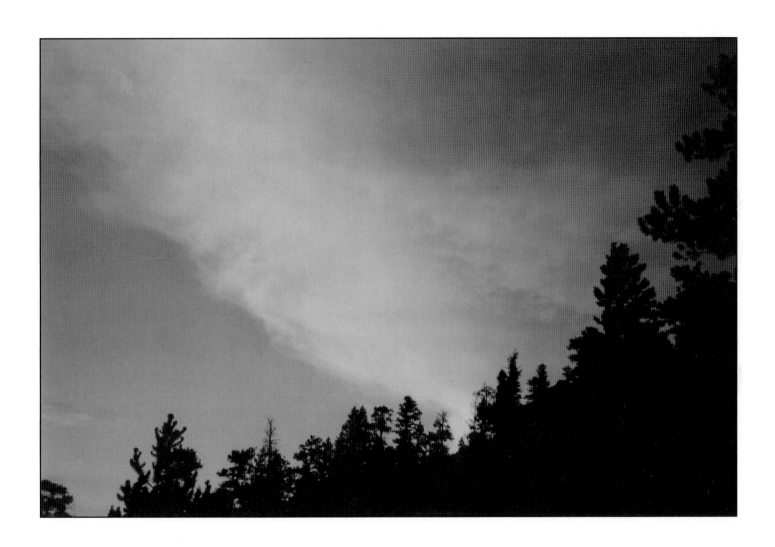

Einsamkeit

I wend my way with heavy step through the busy lives of others, alone and unnoticed.

so zieh' ich meine Straße dahin mit trägem Fuß,
durch helles, frohes Leben einsam und ohne Gruß.

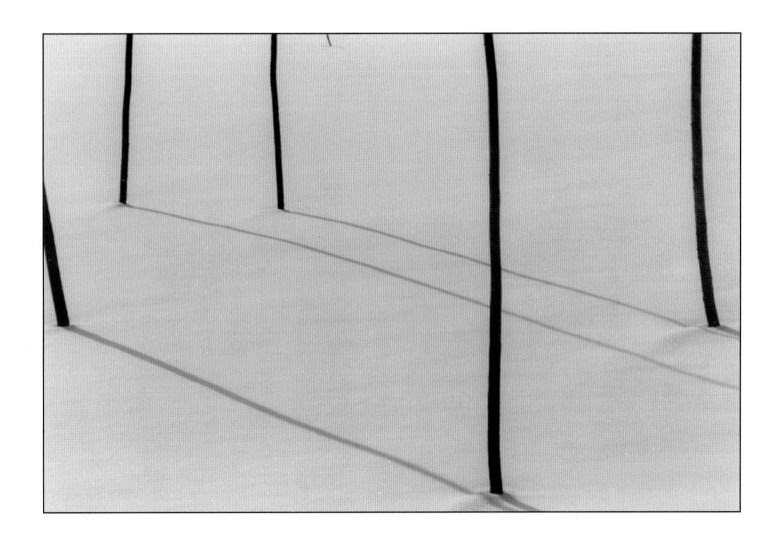

Einsamkeit

How gentle the air is! How bright the world seems!

Ach, daß die Luft so ruhig, ach, daß die Welt so licht!

>─┤◆─○─◆├─<

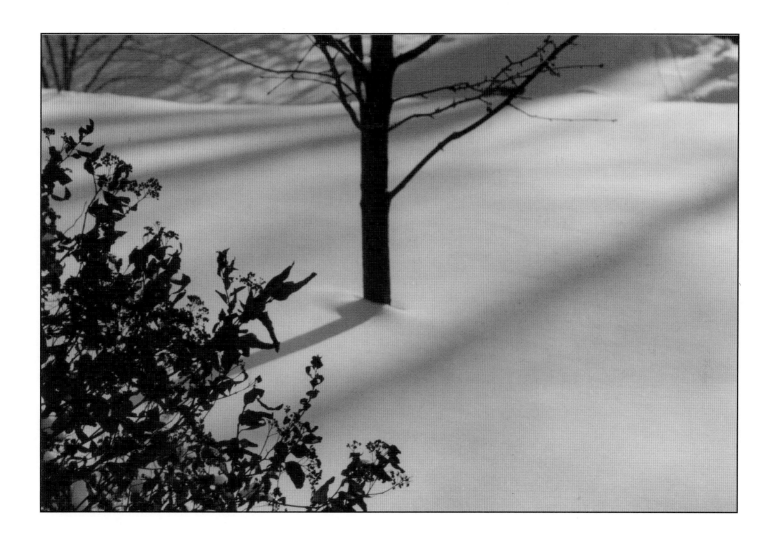

Einsamkeit

Even the raging storms did not rain upon me the misery that I feel now.

Als noch die Stürme tobten, war ich so elend nicht.

⊱⊶⊙⊷⊰

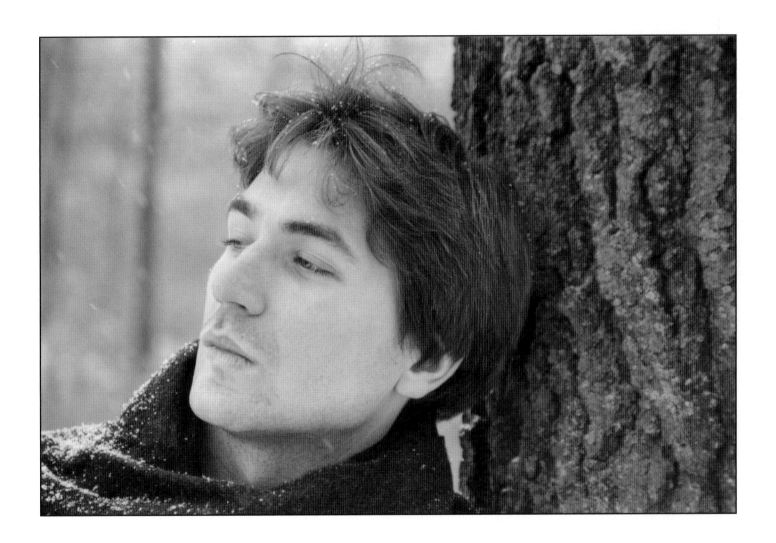

Einsamkeit

 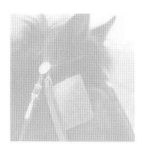

XIII. The Mail—*Die Post*

Why do you leap up, my heart, at the sound of the postman's horn on the road?

Von der Straße her ein Posthorn klingt.
Was hat es, daß es so hoch aufspringt, mein Herz?

⤖⬦○⬦⬕

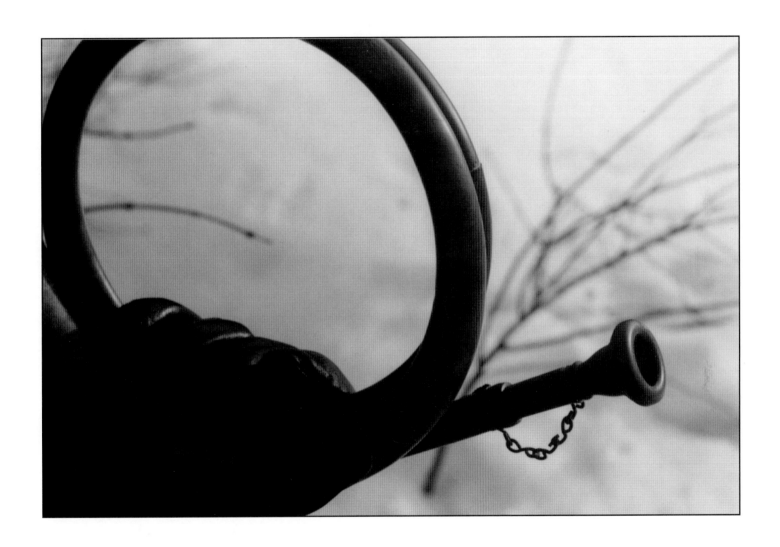

Die Post

There will be no letter for you.

Die Post bringt keinen Brief für dich,

>–◦–◦–◦–◦–◦–◦–◦–◦–◦–◦–◦◦◦◦–<

Why are you now so oddly agitated?

was drängst du denn so wunderlich, mein Herz?

⊱⊶⊙⊷⊰

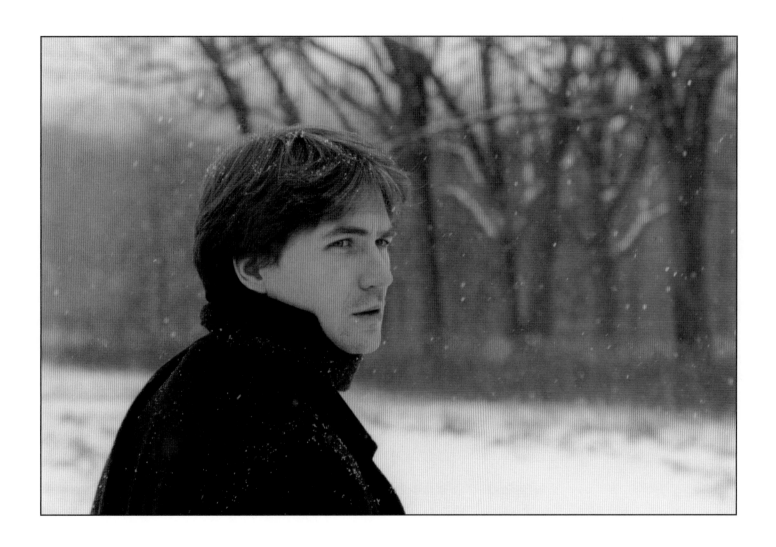

Die Post

Yes, the mail comes from the town where I once had a sweetheart.

Nun ja, die Post kommt aus der Stadt, wo ich ein liebes Liebchen hatt', mein Herz.

<div align="center">⊱┄◆┄○┄◆┄⊰</div>

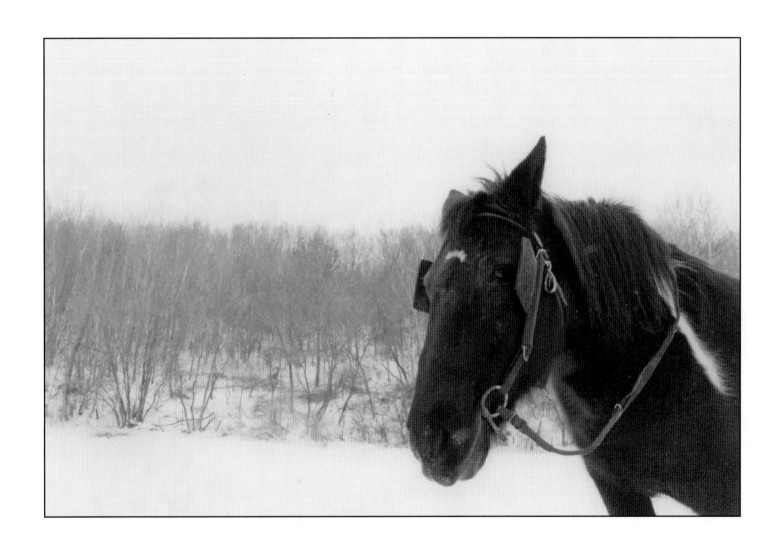

Die Post

You want to take a look over there and see how she is, don't you?

Willst wohl einmal hinüberseh'n und fragen, wie es dort mag geh'n, mein Herz?

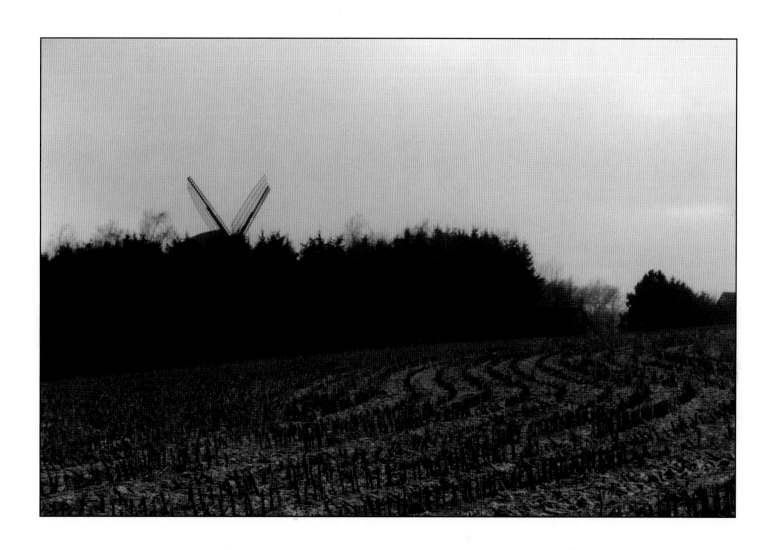

Die Post

XIV. The Aging One—*Der greise Kopf*

This morning my hair shone white, covered with crystals of frost. I fancied I'd become an old man and took great joy in this.

Der Reif hatt' einen weißen Schein mir über's Haar gestreuet;
da glaubt' ich schon ein Greis zu sein und hab' mich sehr gefreuet.

⊰·❖·⊱

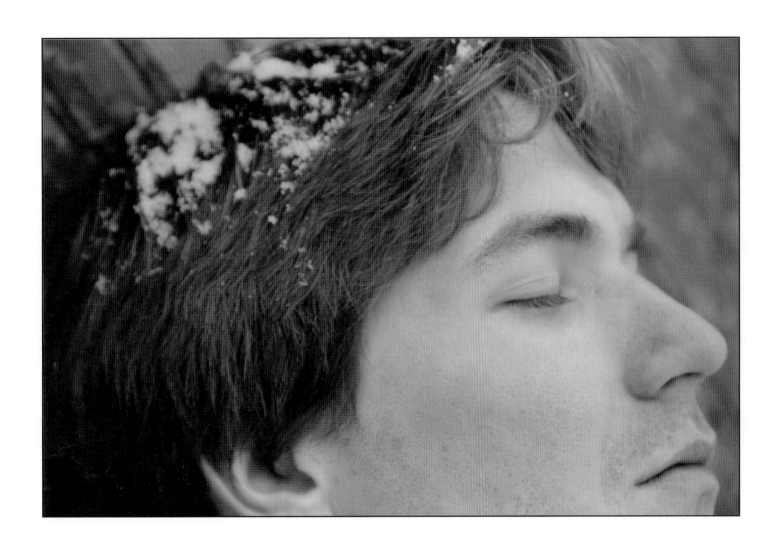

Der greise Kopf

Soon the crystals thawed and my hair turned black again.
I felt a horror of my youth.

Doch bald ist er hinweggetaut, hab' wieder schwarze Haare,
daß mir's vor meiner Jugend graut—

>−+♦−○−♦+−<

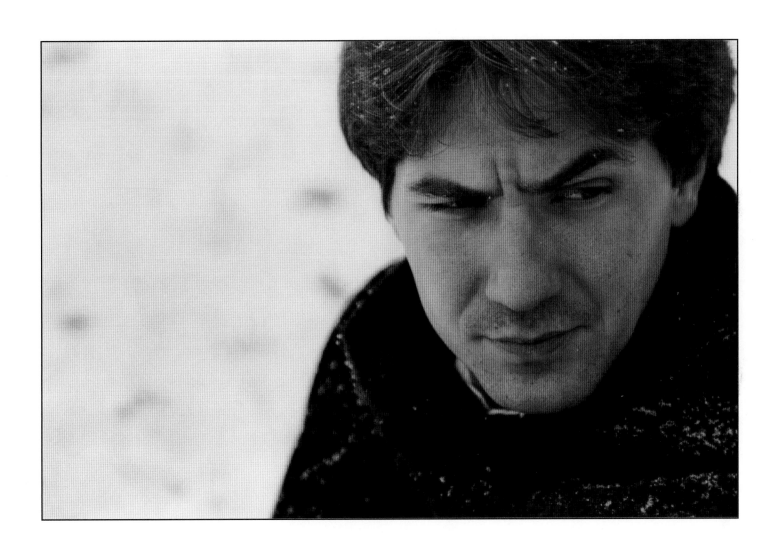

Der greise Kopf

How distant the grave still seems!

wie weit noch, bis zur Bahre!

> ⤞⤜

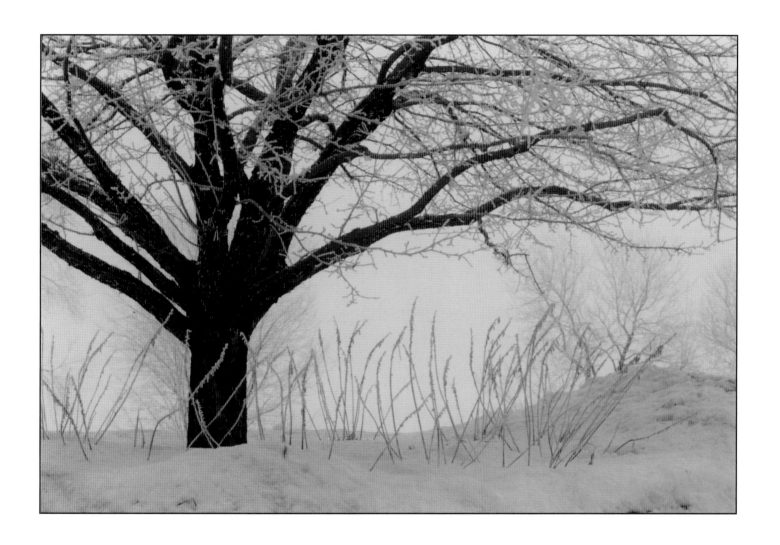

Der greise Kopf

There are those who reach old age in the course of
a single night.

Vom Abendrot zum Morgenlicht ward mancher Kopf zum Greise.

⊱⊰⊙⊱⊰

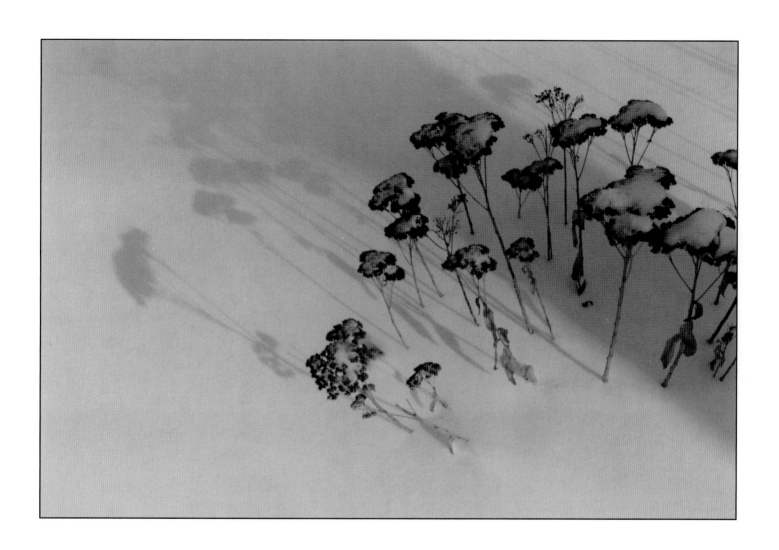

Der greise Kopf

Who would believe that I have not one gray hair to show for my entire journey?

Wer glaubt's? und meiner ward es nicht auf dieser ganzen Reise.

>—⬩—○—⬩—<

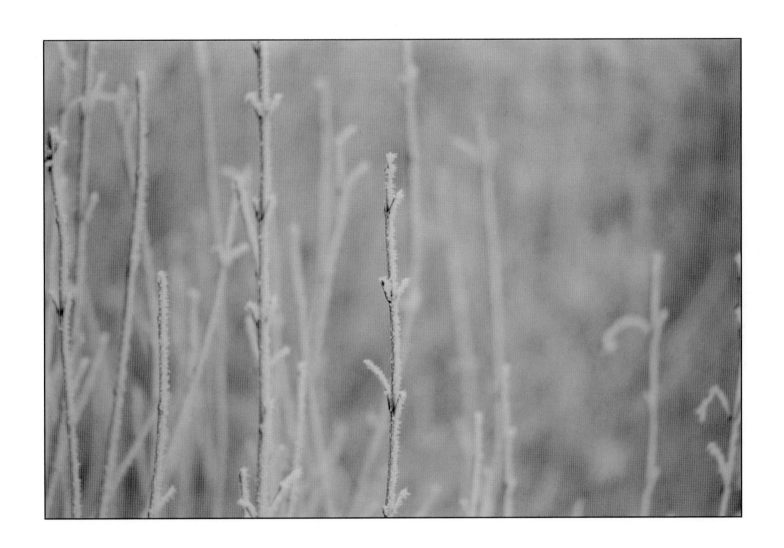

Der greise Kopf

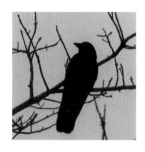 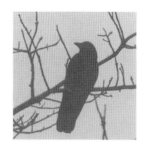 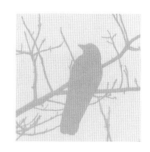

XV. The Crow—*Die Krähe*

A crow has flown with me ever since I left the town,
circling above me over and over again.

Eine Krähe war mit mir aus der Stadt gezogen,
ist bis heute für und für um mein Haupt geflogen.

>—I—O—I—<

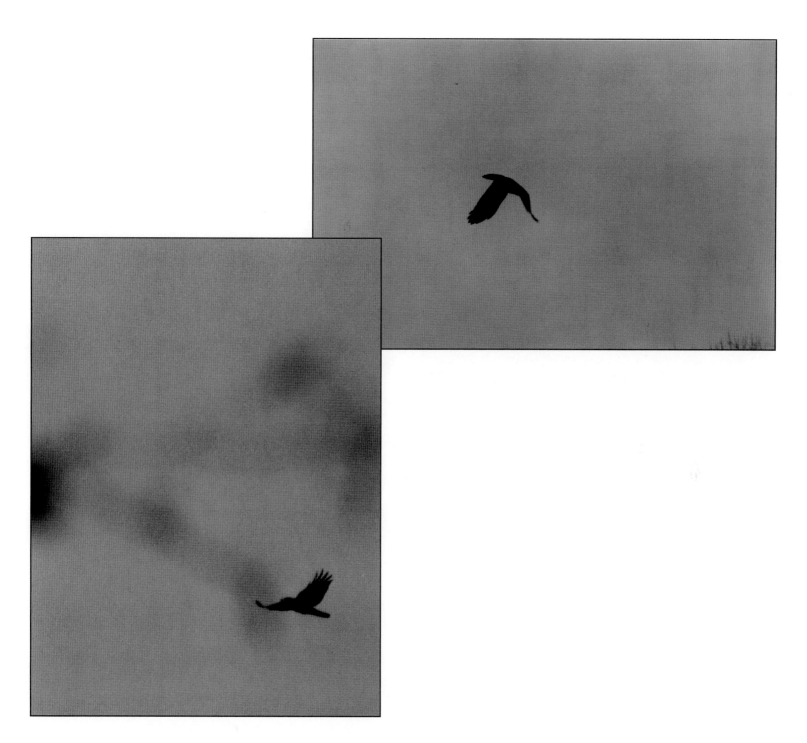

Die Krähe

Strange creature, are you reluctant to leave me?

Krähe, wunderliches Tier, willst mich nicht verlassen?

>-I-◆-O-◆-I-<

Die Krähe

Do you mean to seize my body soon as your prey?
I haven't much farther to go with this walking staff.

Meinst wohl bald als Beute hier meinen Leib zu fassen?

Nun, es wird nicht weit mehr geh'n an dem Wanderstabe,

>·I·◆·•·O·•·◆·I·<

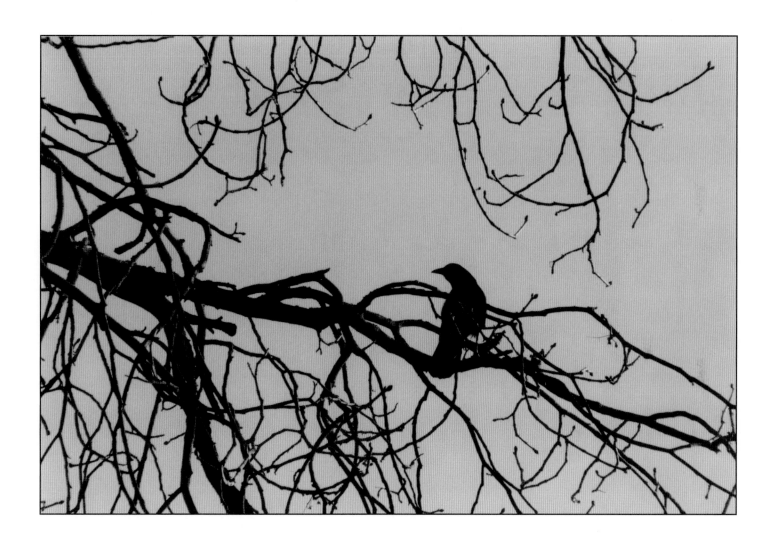

Die Krähe

Crow, let me see at last what it means to be faithful to the grave.

Krähe, laß mich endlich seh'n Treue bis zum Grabe!

>⊶⊶◦⊷⊶<

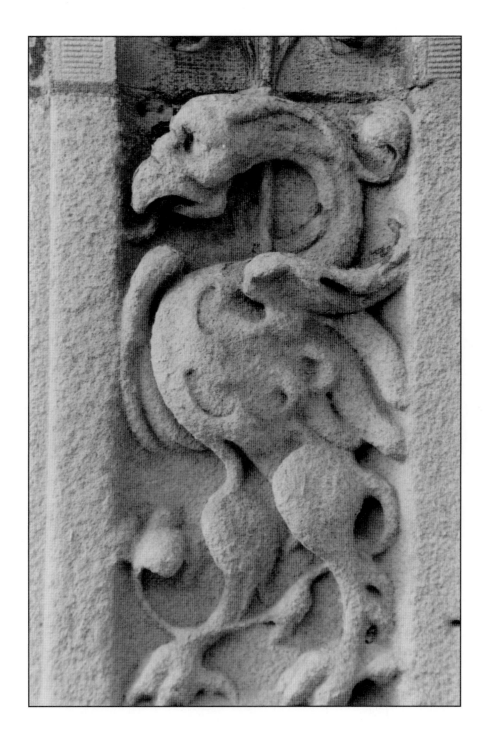

Die Krähe

XVI. Last Hope—*Letzte Hoffnung*

Here and there colored leaves can be seen on the trees.

Hie und da ist an den Bäumen manches bunte Blatt zu seh'n,

⟩—⟨⟩—◦—⟨⟩—⟨

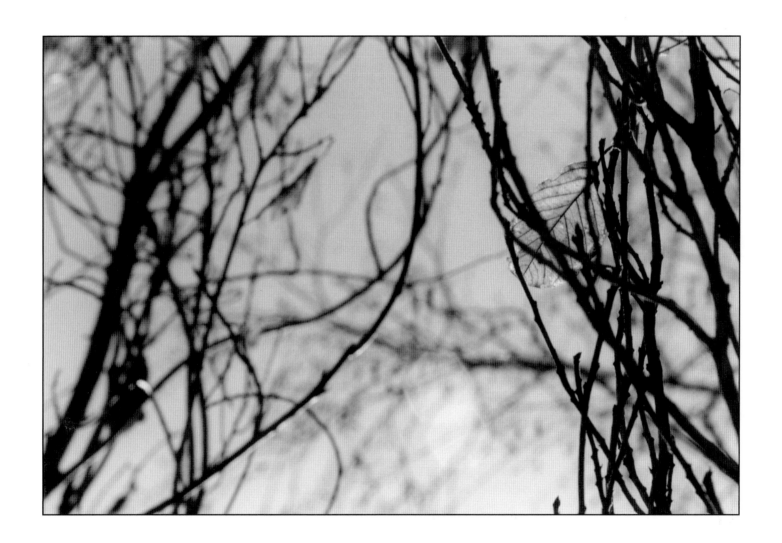

Letzte Hoffnung

I often stop, lost in thought, and fix my gaze on a single clinging leaf. The leaf becomes a vision of my hope.

und ich bleibe vor den Bäumen oftmals in Gedanken steh'n.

Schaue nach dem einen Blatte, hänge meine Hoffnung dran,

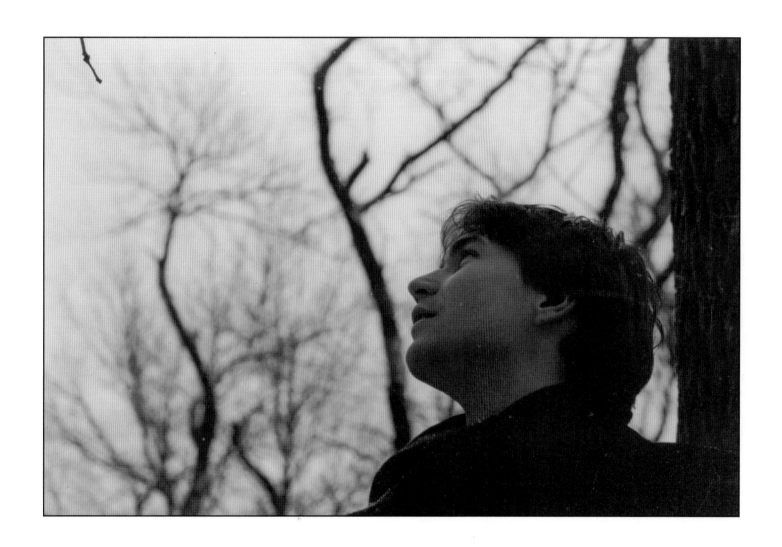

Letzte Hoffnung

If the wind teases my leaf, a shudder pulses through my
body. Ah, and if the leaf falls to the ground, hope falls with it;

spielt der Wind mit meinem Blatte, zittr' ich, was ich zittern kann.

Ach, und fällt das Blatt zu Boden, fällt mit ihm die Hoffnung ab;

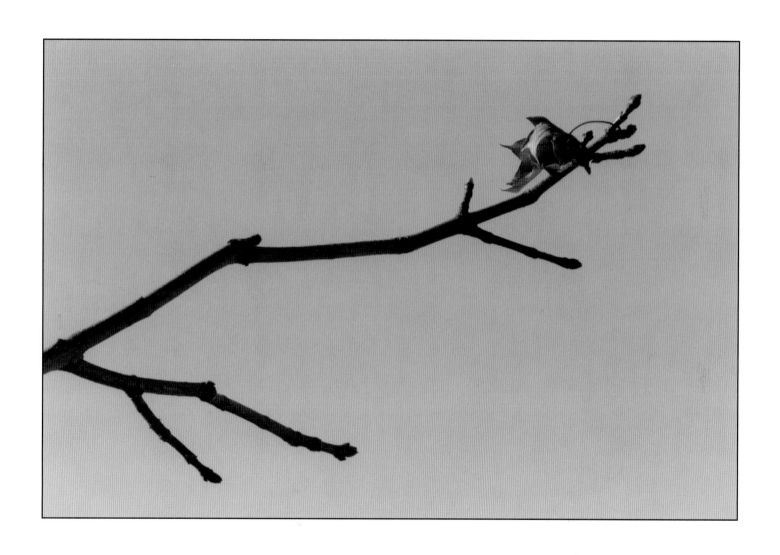

Letzte Hoffnung

I myself sink to the ground and weep on the tomb of my hope.

fall' ich selber mit zu Boden, wein' auf meiner Hoffnung Grab.

>—┤◆>—○—<◆├—<

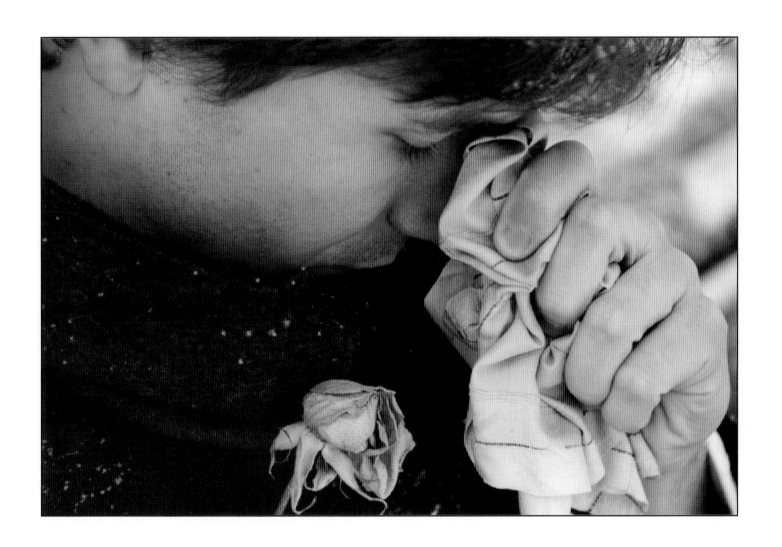

Letzte Hoffnung

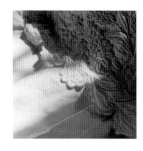

XVII. In the Village—*Im Dorfe*

Dogs are barking, rattling their chains. People are sleeping in their beds, dreaming sweet dreams of desire, amusing themselves with the good and the wicked.

Es bellen die Hunde, es rasseln die Ketten, es schlafen die Menschen in ihren Betten;
träumen sich Manches, was sie nicht haben, tun sich im Guten und Argen erlaben.

>⊹>◦<⊹<

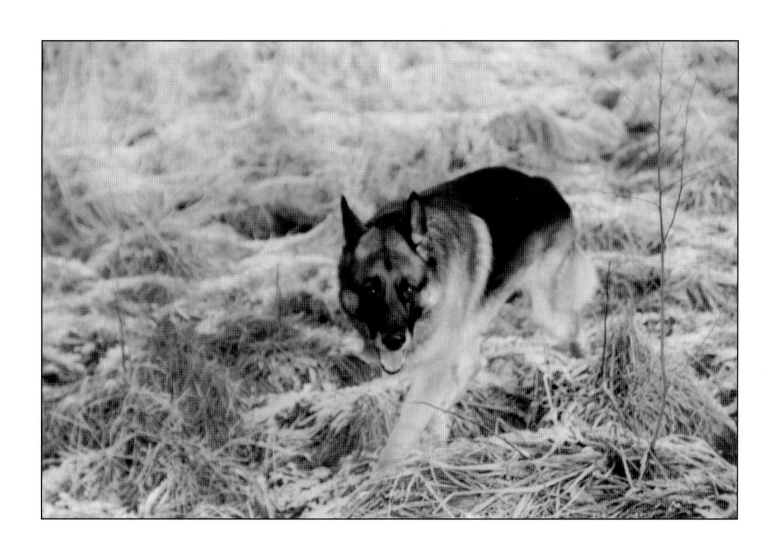

Im Dorfe

In the morning all will be as it was before.

Und morgen früh ist alles zerflossen.

⊱ ⊰⊱ ⊙ ⊰⊱ ⊰

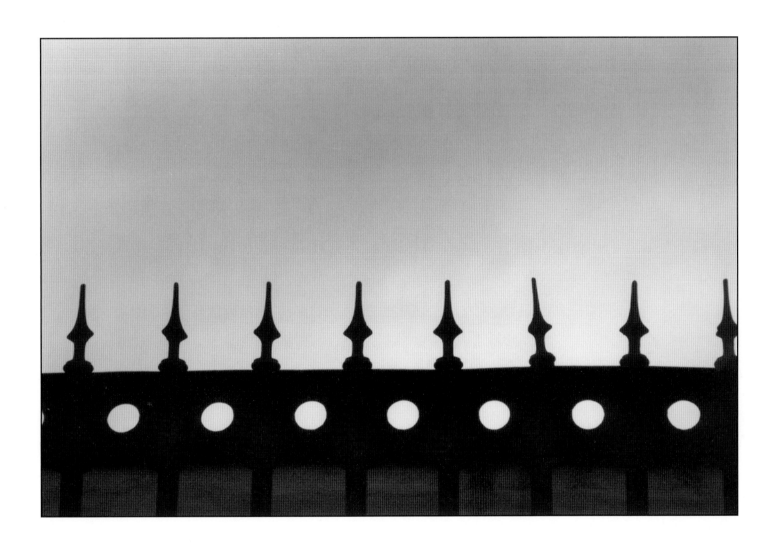

Im Dorfe

Still, they have had their moment of pleasure and hope to find what remains of it when they return to their pillows.

Je nun, sie haben ihr Teil genossen, und hoffen, was sie noch übrig ließen, doch wieder zu finden auf ihren Kissen.

>─┼─◆─○─◆─┼─◄

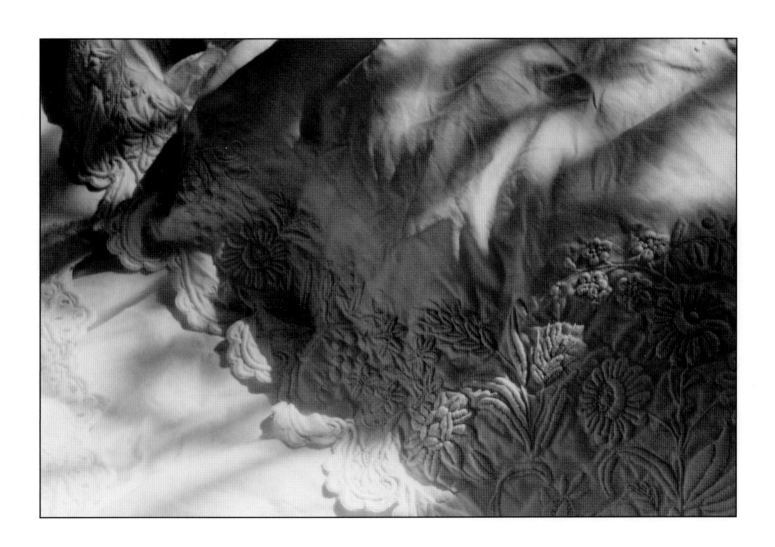

Im Dorfe

Dogs of the night, pray keep on barking! Don't let me sleep!

Bellt mich nur fort, ihr wachen Hunde, laßt mich nicht ruh'n in der Schlummerstunde!

>–‹�«›•–O–‹«›•‹–

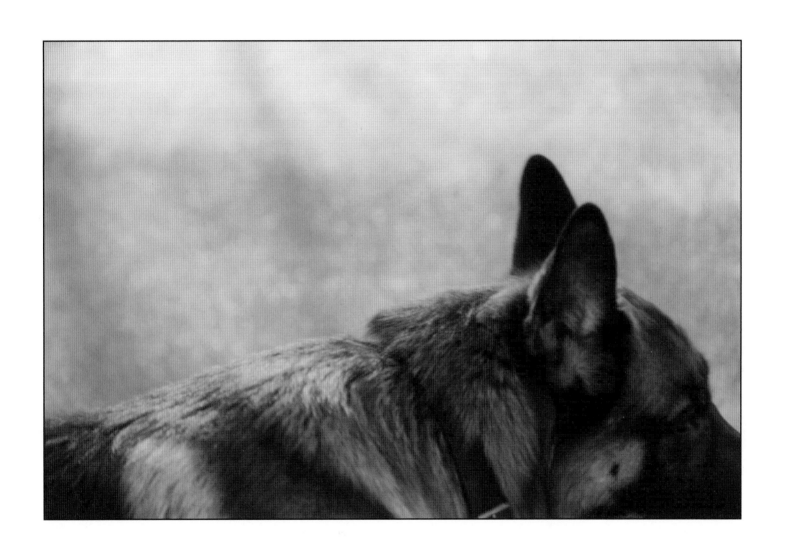

Im Dorfe

I am finished with dreaming. Why should I tarry with those who are slumbering?

Ich bin zu Ende mit allen Träumen, was will ich unter den Schläfern säumen?

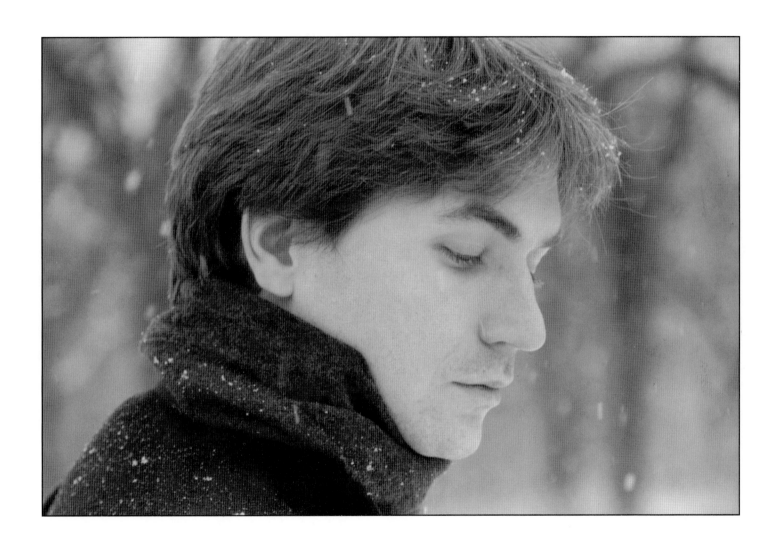

Im Dorfe

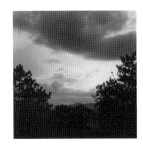 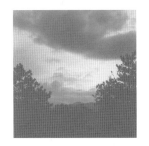

XVIII. The Stormy Morning—*Der stürmische Morgen*

How violently the storm has torn apart the gray fabric of
the sky, leaving shreds of cloud flapping about in listless conflict!

Wie hat der Sturm zerrissen des Himmels graues Kleid!
Die Wolkenfetzen flattern umher in mattem Streit.

>—◇—○—◇—I—

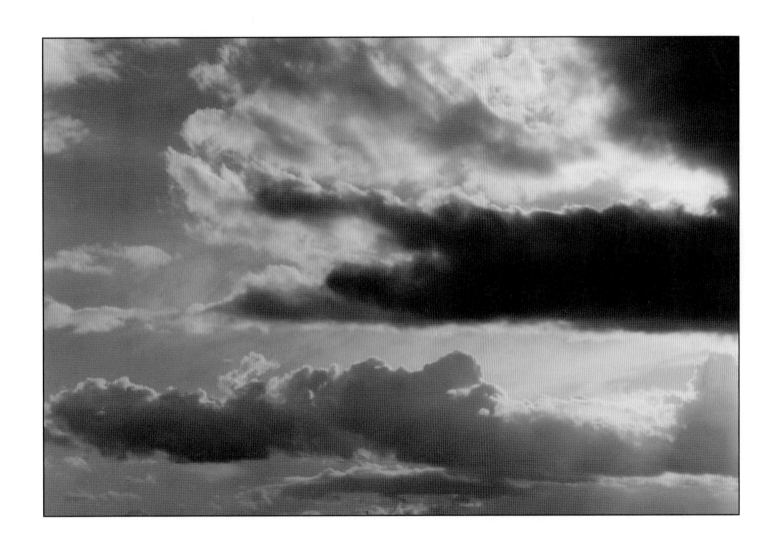

Der stürmische Morgen

Fiery flames dart amidst them.

Und rote Feuerflammen zieh'n zwischen ihnen hin;

>‒‣⊙‹‒‹

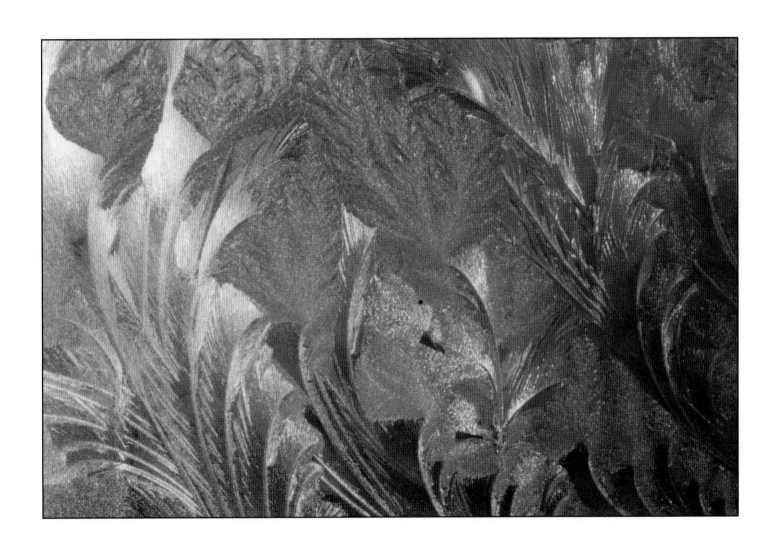

Der stürmische Morgen

It is indeed a morning to fit my mood!

das nenn' ich einen Morgen so recht nach meinem Sinn.

>-·-♦-·-O-·-♦-·-<

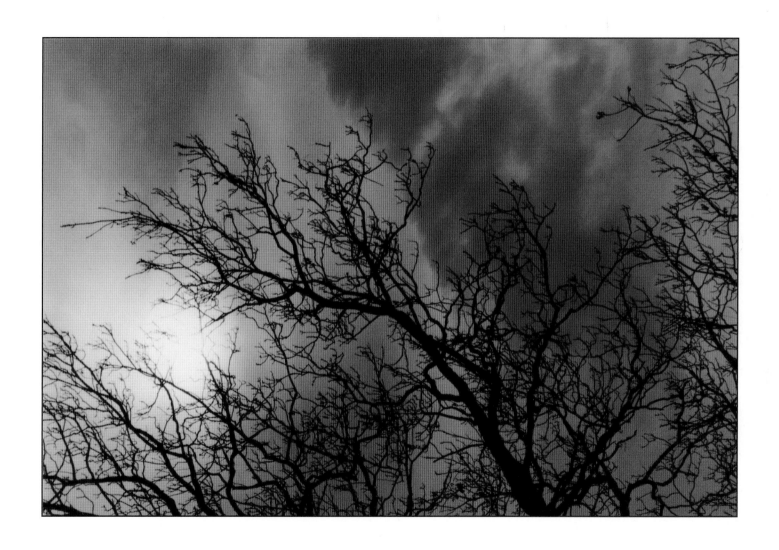

Der stürmische Morgen

My heart recognizes in the sky the reflection of its own image: it is nothing more than winter—cold, raw winter!

Mein Herz sieht an dem Himmel gemalt sein eig'nes Bild—
es ist nichts als der Winter, der Winter kalt und wild.

>-I-◆-○-◆-I-<

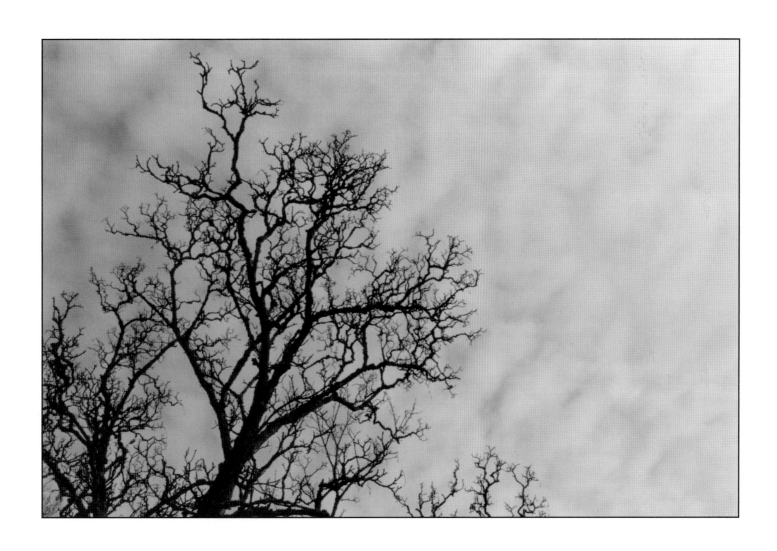

Der stürmische Morgen

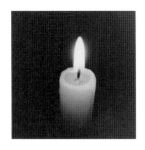 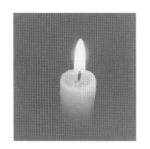 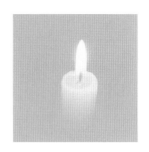

XIX. Delusion—*Täuschung*

A friendly light dances before my eyes, enticing me this way and that.

Ein Licht tanzt freundlich vor mir her, ich folg' ihm nach die Kreuz und Quer;

>—◦—◦—

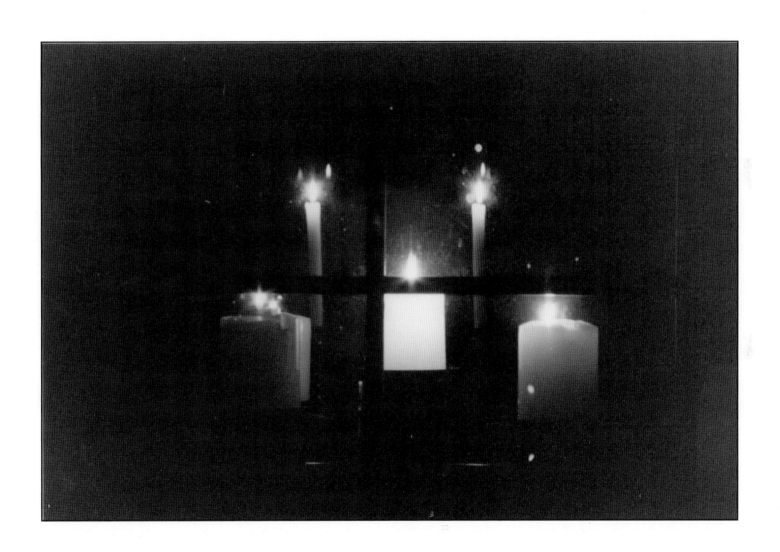

Täuschung

I gladly follow its seductive glow, for I am a weary traveler.
Those in misery willingly succumb to trickery.

Ich folg' ihm gern und seh's ihm an, daß es verlockt den Wandersmann.
Ach, wer wie ich so elend ist, gibt gern sich hin der bunten List,

>⊷⊶⊙⊷⊶⊰

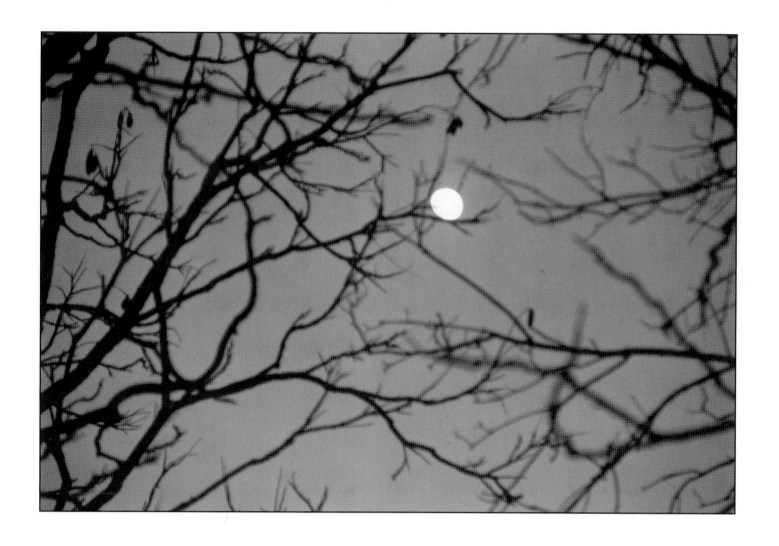

Täuschung

Beyond the ice, horror, and dark of night, a warm bright cottage beckons, a loving soul awaits.

die hinter Eis und Nacht und Graus ihm weist ein helles, warmes Haus,
und eine liebe Seele drin—

>‐ ◄►‐ ○ ‐ ◄► ‐ ◄

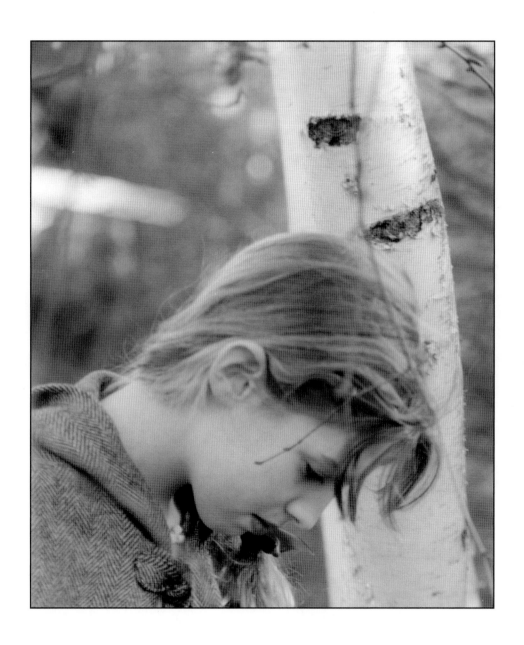

Täuschung

Even delusion can be a blessing for one such as I.

Nur Täuschung ist für mich Gewinn!

⋗–⬩⧫⬩–◯–⬩⧫⬩–⋖

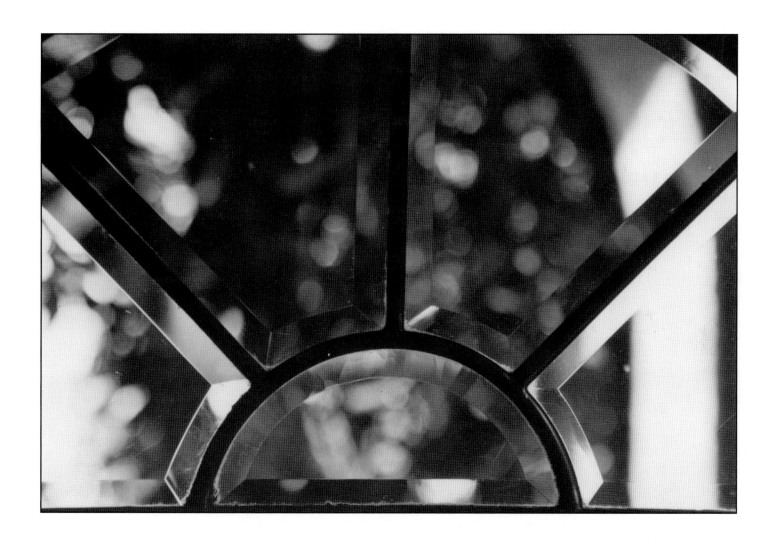

Täuschung

XX. The Signpost—*Der Wegweiser*

For what reason do I avoid the well-trod paths of other
travelers and seek instead the hidden trails of snow-covered
rocky cliffs?

Was vermeid' ich denn die Wege, wo die andern Wandrer geh'n,
suche mir versteckte Stege durch verschneite Felsenhöh'n?

>─┤◄►─○─◄┤◄

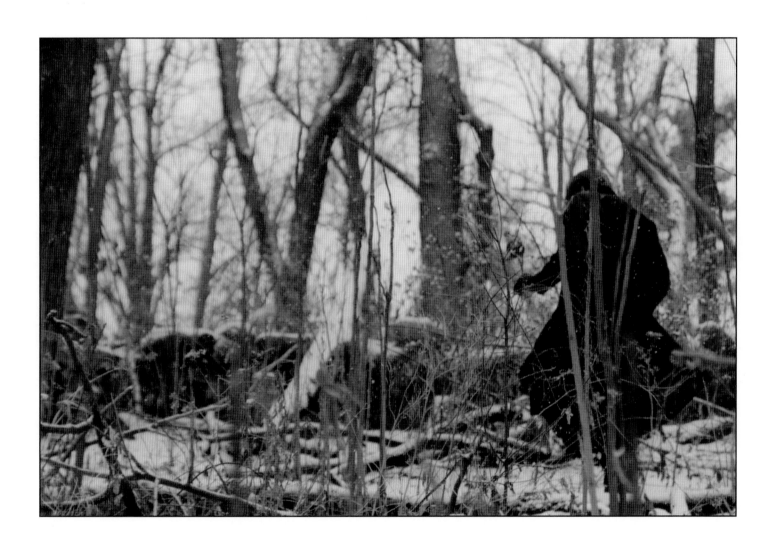

Der Wegweiser

I have done no wrong, that I should reject the company of mankind.

Habe ja doch nichts begangen, daß ich Menschen sollte scheu'n,

⟶—◦—⟵

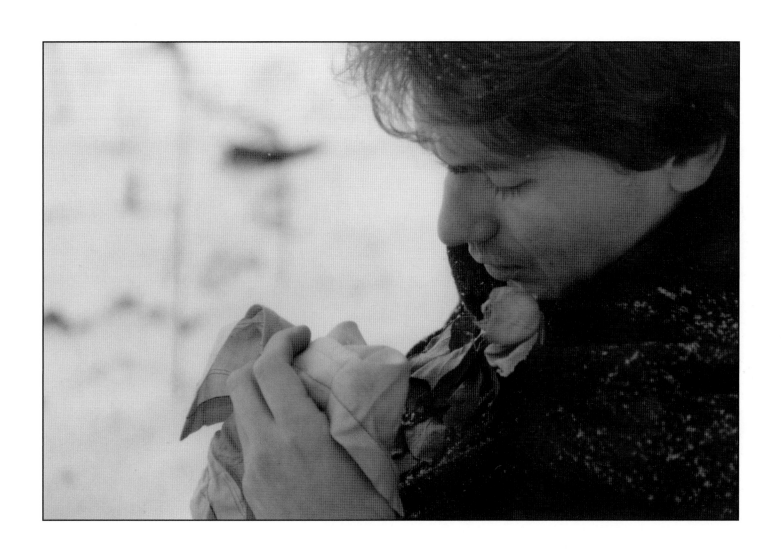

Der Wegweiser

What foolish desire drives me into these desolate places?

welch ein törichtes Verlangen treibt mich in die Wüstenei'n?

➤—ı—◆➤—○—◄◆—ı—◄

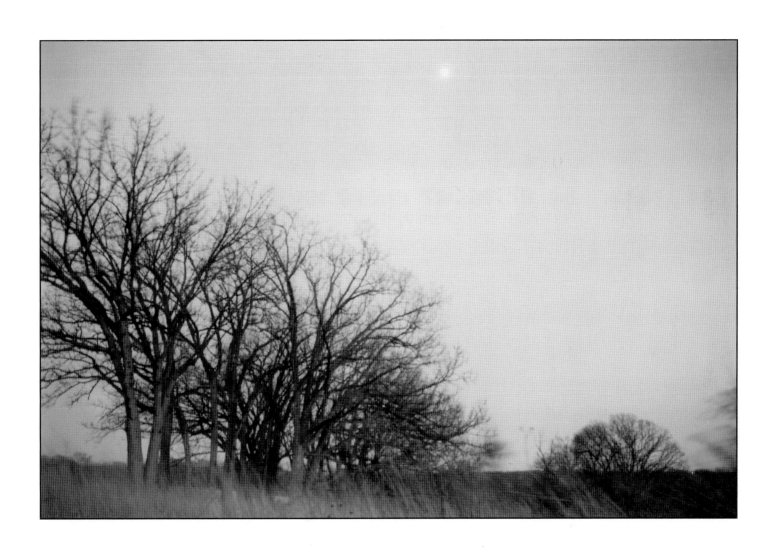

Der Wegweiser

There are signposts on every road, pointing to the towns;
yet I wander without direction, restless, in search of solace.

Weiser stehen auf den Straßen, weisen auf die Städte zu,
und ich wandre sonder Maßen, ohne Ruh', und suche Ruh'.

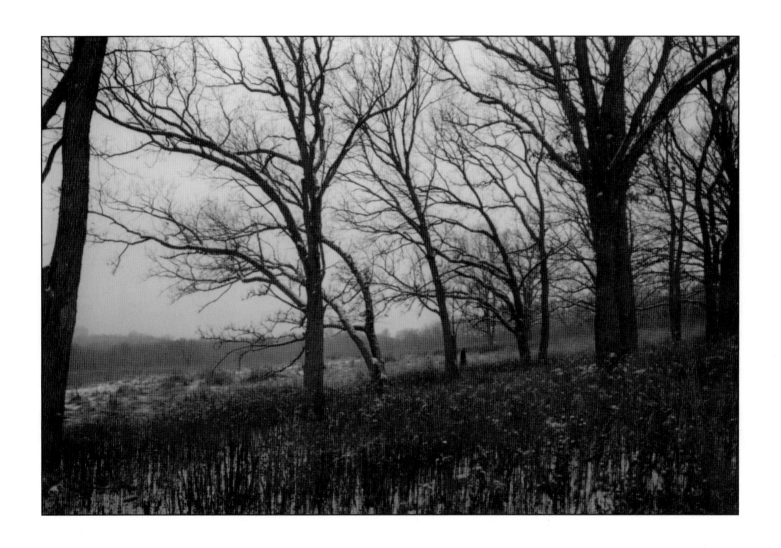

Der Wegweiser

A signpost, unwavering before my eyes, leads me down a
road from which there is no return.

Einen Weiser seh' ich stehen unverrückt vor meinem Blick;
eine Straße muß ich gehen, die noch keiner ging zurück.

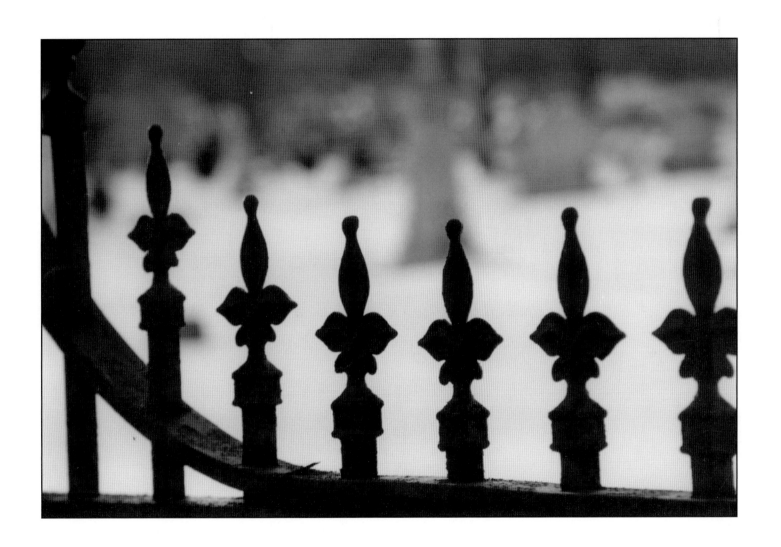

Der Wegweiser

XXI. The Inn—*Das Wirtshaus*

My path has led me to a graveyard.

Auf einen Totenacker hat mich mein Weg gebracht,

━━◆━○━◆━━

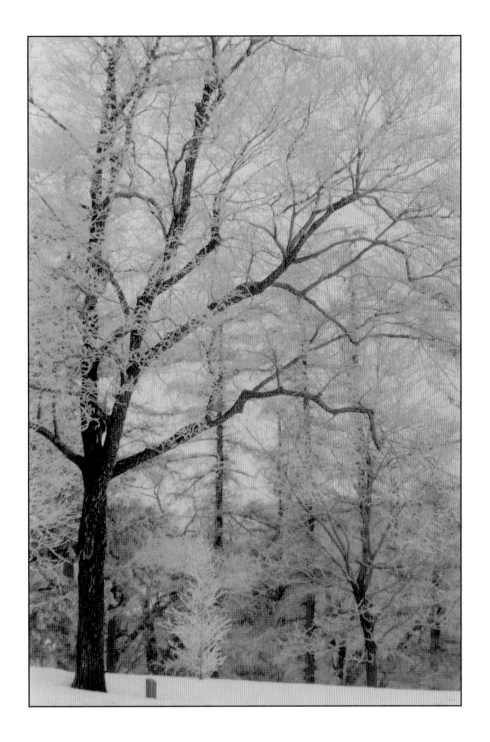

Das Wirtshaus

Here I shall go in.

allhier will ich einkehren, hab' ich bei mir gedacht.

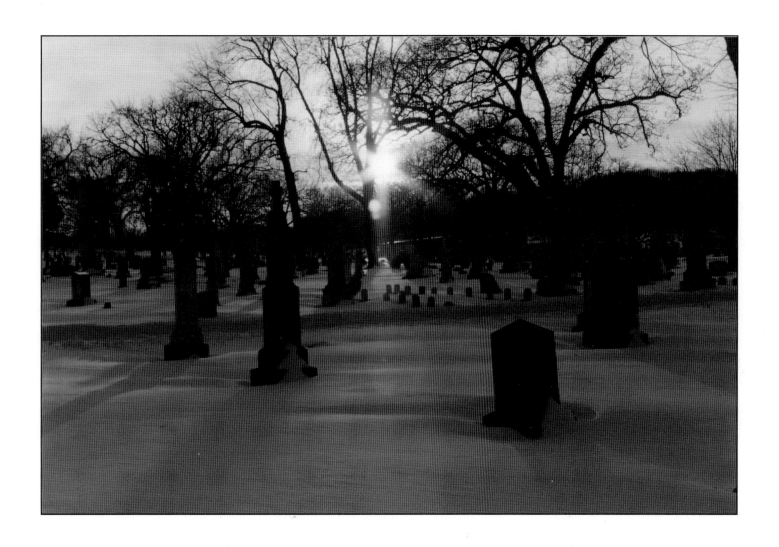

Das Wirtshaus

Its green wreaths seem to invite weary travelers to enter, as if into a cool inn.

Ihr grünen Totenkränze könnt wohl die Zeichen sein,
die müde Wandrer laden ins kühle Wirtshaus ein.

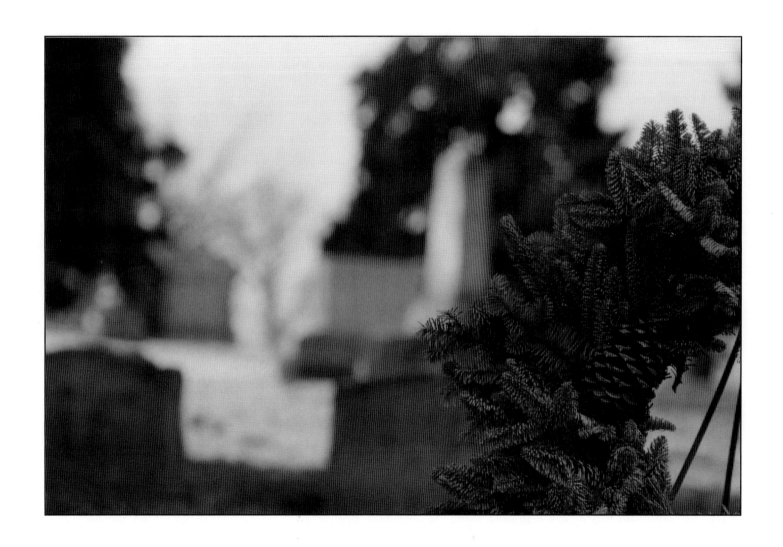

Das Wirtshaus

Are all the rooms in this house filled? I am exhausted and near collapse, mortally wounded.

Sind denn in diesem Hause die Kammern all' besetzt?
Bin matt zum Niedersinken, bin tödlich schwer verletzt.

⊱┤◆⟩•○•⟨◆├⊰

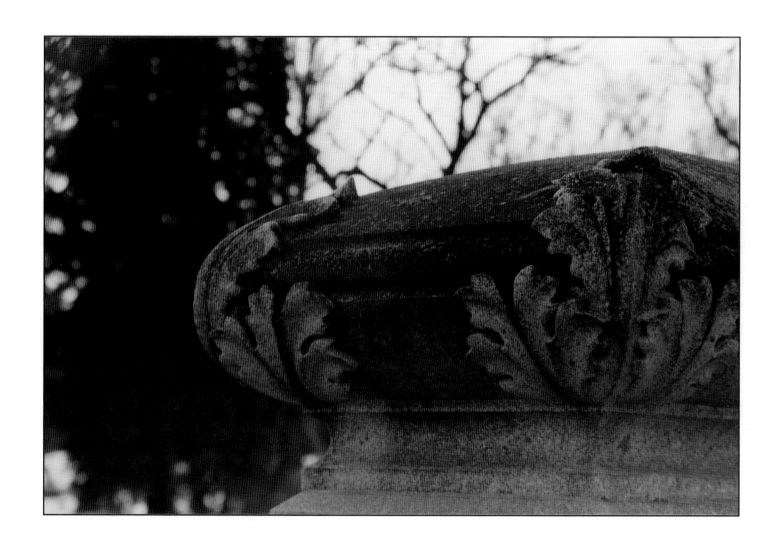

Das Wirtshaus

The Inn

Oh cruel inn, are you turning me away?

O unbarmherz'ge Schenke, doch weisest du mich ab?

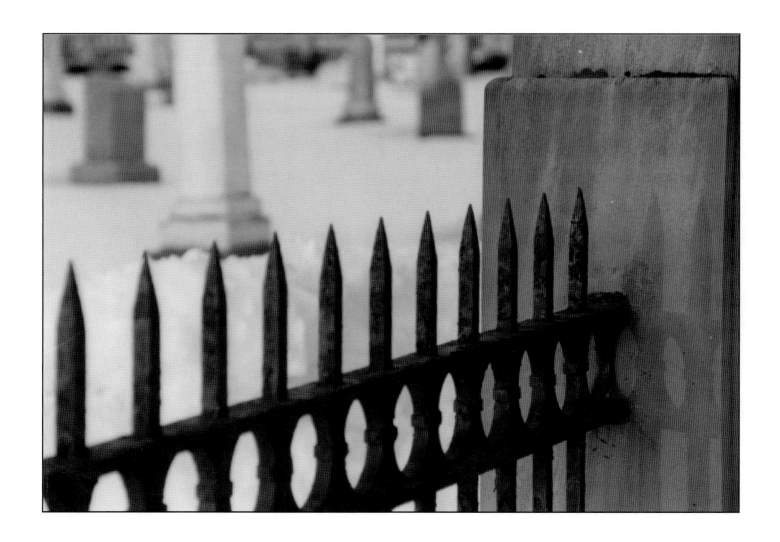

Das Wirtshaus

Then we must trudge on, my faithful walking staff and I.

Nun weiter denn, nur weiter, mein treuer Wanderstab!

⤜•◆•○•◆•⤛

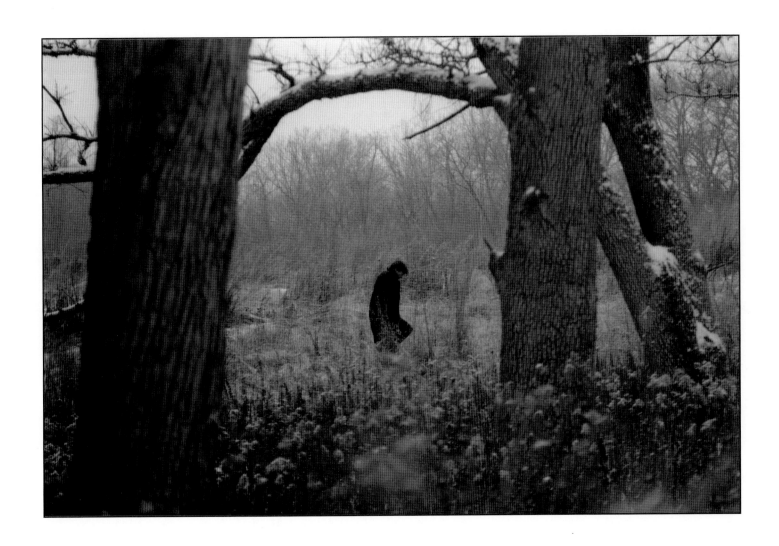

Das Wirtshaus

XXII. Courage—*Mut*

Let the snow fly in my face. See how I shake it off! Let my heart wail in my breast. See how loud and cheerfully I sing!

Fliegt der Schnee mir ins Gesicht schüttl' ich ihn herunter.
Wenn mein Herz im Busen spricht, sing' ich hell und munter.

>—I—▶—O—◀—I—

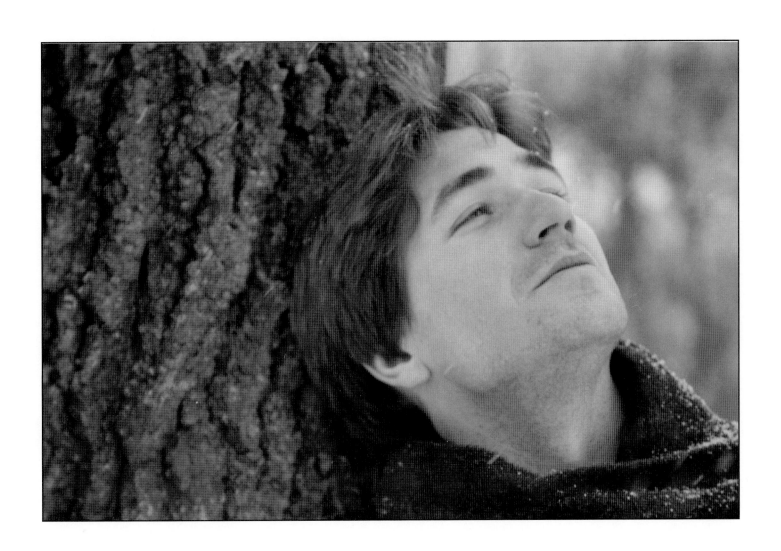

Mut

I can't even hear what it's saying—I have no ears. I am numb to its complaints—complaining is for fools!

Höre nicht, was es mir sagt, habe keine Ohren.
Fühle nicht, was es mir klagt, klagen ist für Toren.

⟩⟨◆⟩⟨○⟩⟨◆⟩⟨

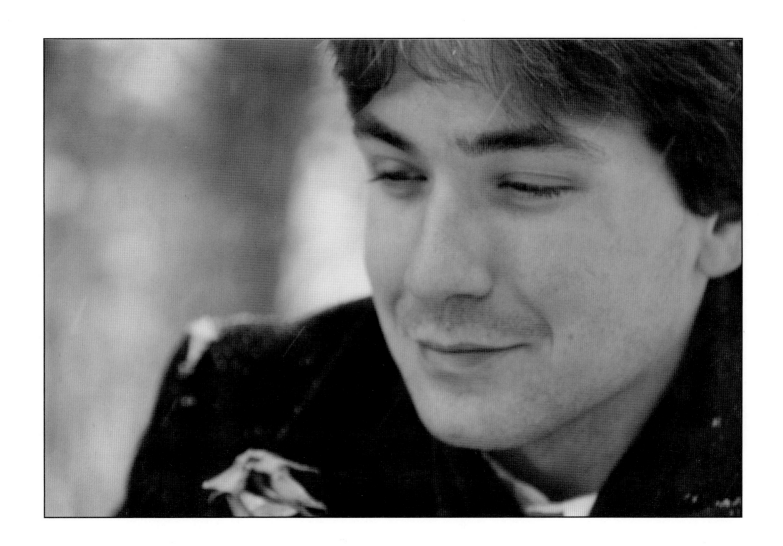

Mut

Joyfully I stride through the world, with no thought of wind and weather. If there be no God on earth, then we ourselves must be gods!

Lustig in die Welt hinein gegen Wind und Wetter;
will kein Gott auf Erden sein, sind wir selber Götter!

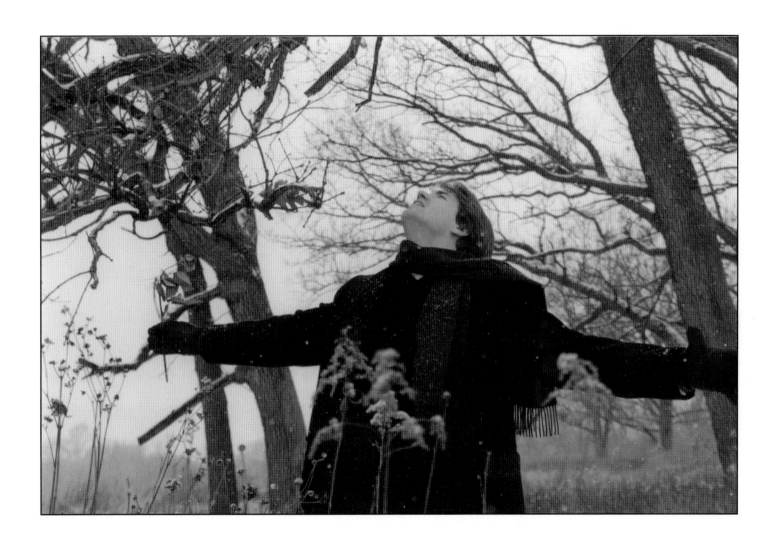

Mut

XXIII. The Phantom Suns—*Die Nebensonnen*

I saw three suns outlined against the sky and stared at them intently for a long time. They, too, remained firmly in place, as if they did not wish to leave me.

Drei Sonnen sah ich am Himmel steh'n, hab' lang und fest sie angeseh'n.
Und sie auch standen da so stier, als wolten sie nicht weg von mir.

>–•–O–•–‹

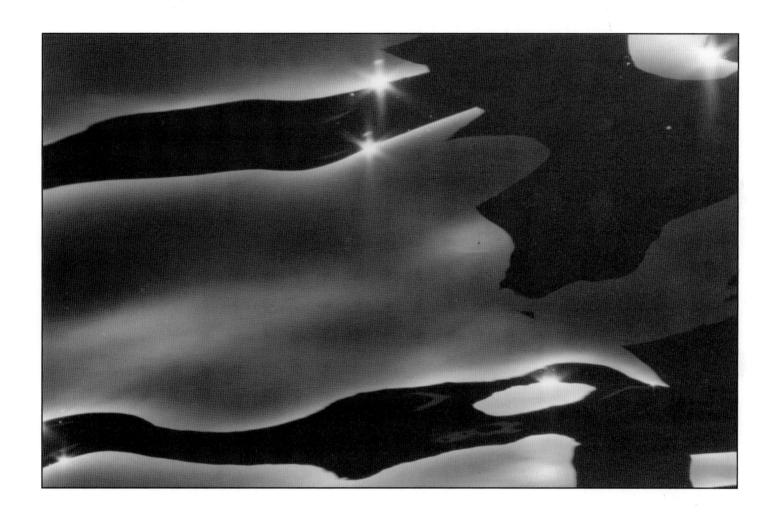

Die Nebensonnen

Alas, you are not *my* suns! You should be gazing instead on the faces of others! Until recently I also had three suns, but now the two most beautiful ones have departed.

Ach, meine Sonnen seid ihr nicht! Schaut andern doch ins Angesicht!
Ach, neulich hatt' ich auch wohl drei; nun sind hinab die besten zwei.

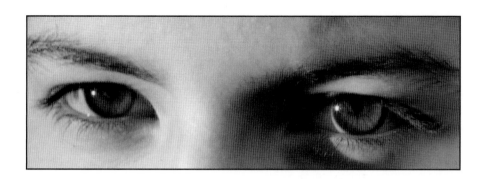

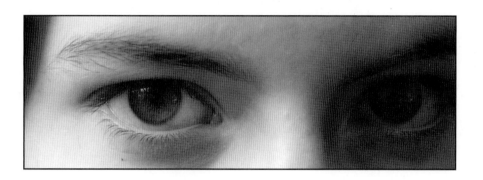

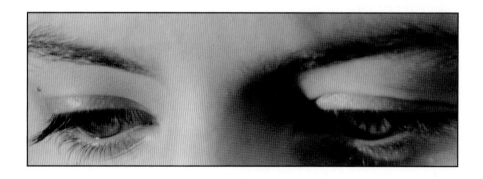

Die Nebensonnen

If only the third would leave as well! Darkness is all
that I crave.

Ging' nur die dritt' erst hinterdrein! Im Dunkeln wird mir wohler sein.

>‑‹‹›‑O‑‹›‹‑‹<

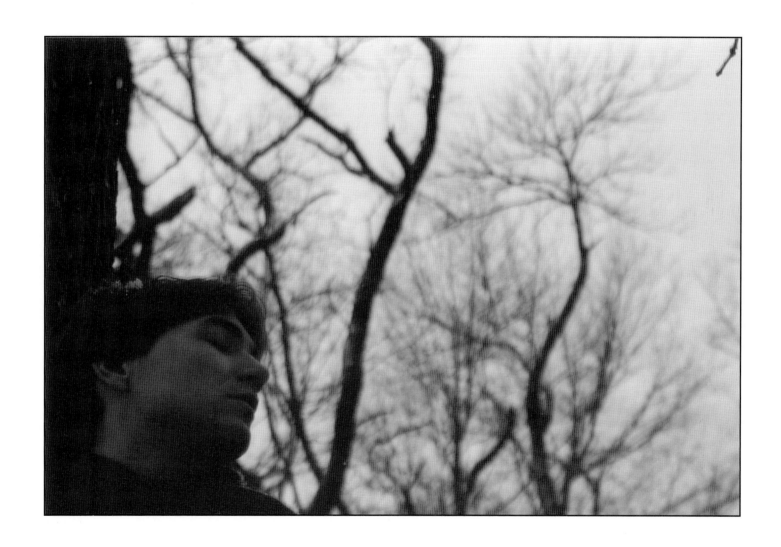

Die Nebensonnen

XXIV. The Hurdy-Gurdy Player—*Der Leiermann*

Just beyond the village is a hurdy-gurdy player. His
numbed fingers crank the handle as best they can. Barefoot,
he wavers back and forth across the ice;

Drüben hinterm Dorfe steht ein Leiermann,
und mit starren Fingern dreht er, was er kann.

Barfuß auf dem Eise wankt er hin and her,

>─◆──○──◆──◁

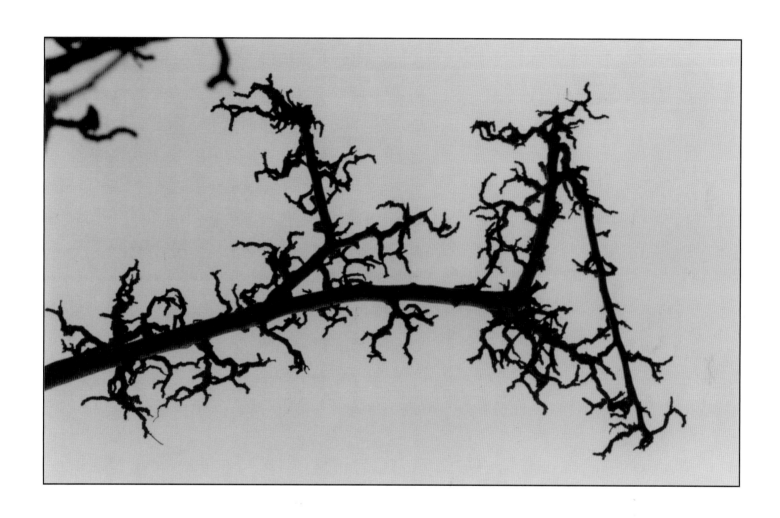

Der Leiermann

yet the little plate remains empty. No one wants to listen,
no one wants to look, and the dogs snarl as they circle him.

und sein kleiner Teller bleibt ihm immer leer.

Keiner mag ihn hören, keiner sieht ihn an,
und die Hunde knurren um den alten Mann.

>—·◄►·—○—·◄►·—‹

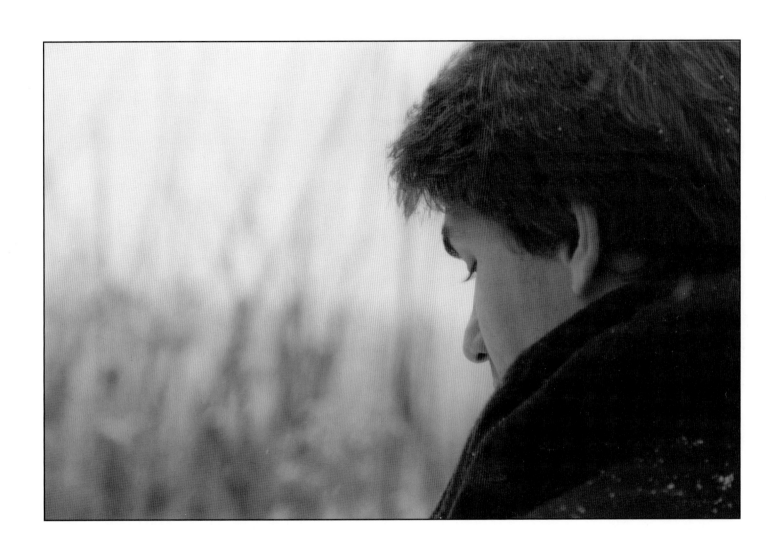

Der Leiermann

He takes no notice of all around him as he plays his tunes, and his music is never silent.

Und er läßt es gehen alles, wie es will,
dreht, und seine Leier steht ihm nimmer still.

⊱┈◈┈○┈◈┈⊰

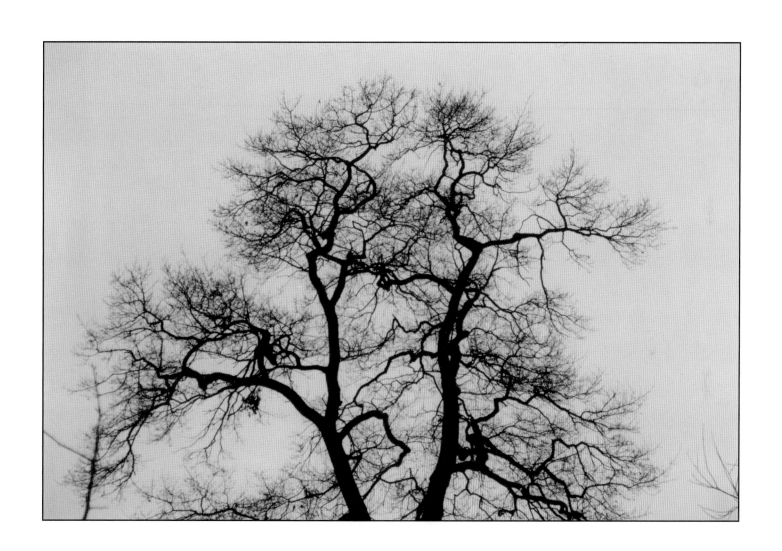

Der Leiermann

Strange old man, shall I go with you? Will you grind your
organ to my songs?

Wunderlicher Alter, soll ich mit dir geh'n?
Willst zu meinen Liedern deine Leier dreh'n?

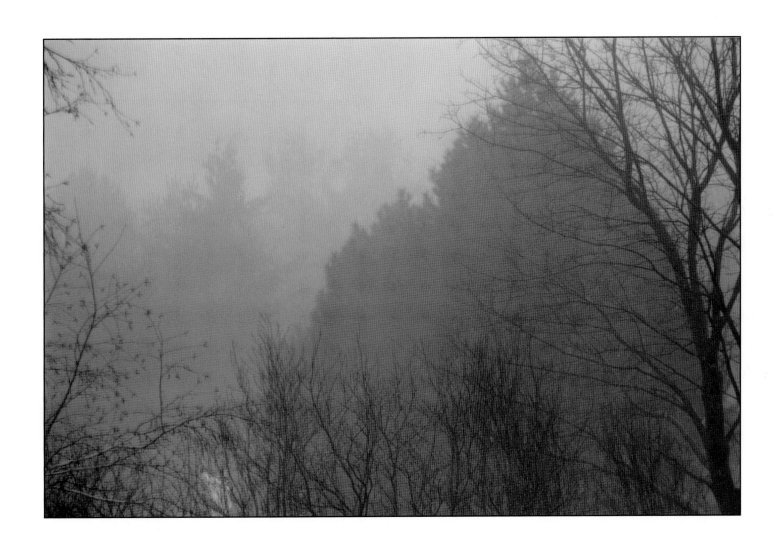

Der Leiermann

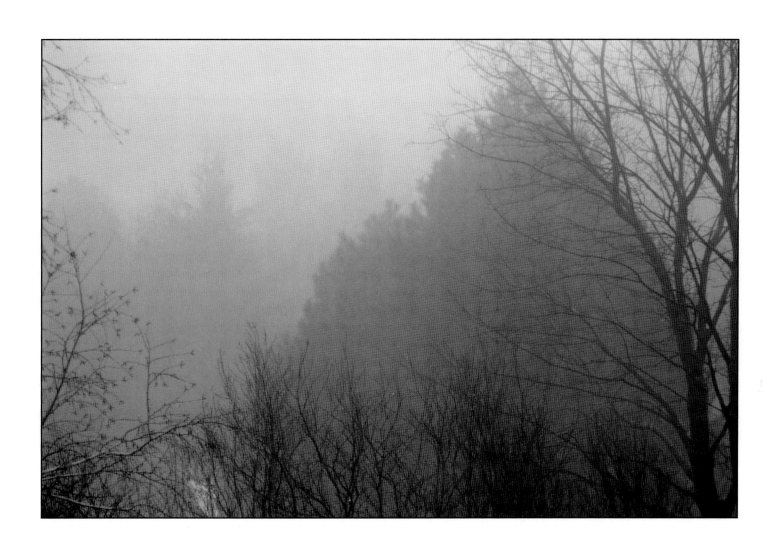

Der Leiermann

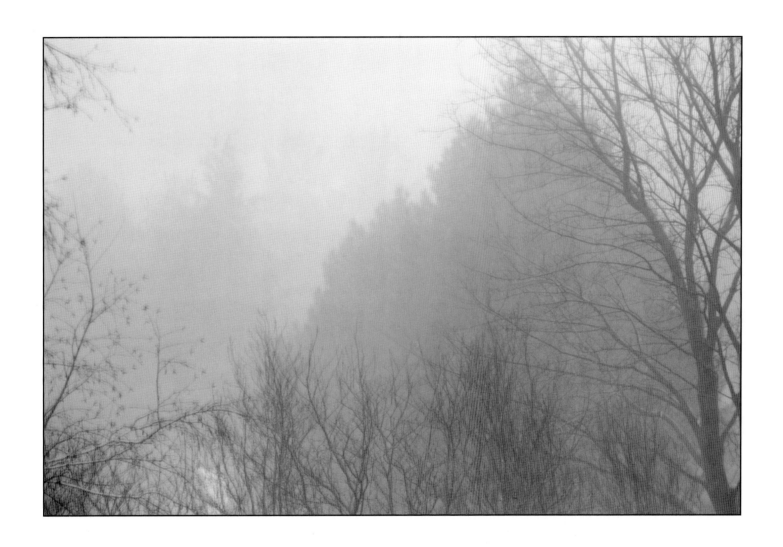

Der Leiermann

Notes on the Photographing of a Song Cycle

Embarking on the intimidating yet invigorating project of illustrating one of the greatest and most desperate song cycles ever written was a journey in itself. By seeking timeless moments, I strove to blur the boundaries between various twentieth and twenty-first century locales and nineteenth century Austria. Images of circles (the broken ring) and angles emerge as visual motives throughout the song cycle, and surprisingly many of our selections naturally suggest these elements (circles in the ice, on the horn, in the horse's bridle). We also discovered that sometimes the images in the photographs aligned with the physical layout of the musical notes for that song, for example, the repeated sharp points of an iron fence seemed hauntingly parallel to the clusters of eighth notes in the score of the song, "Im Dorfe." As the song cycle progresses, the music becomes more abstract, and we were drawn to more abstract suggestions of the despair depicted in the photographs for the later songs.

My deepest thanks go to Paul Rowe for engaging me in this incredible series of projects, and to my beautiful Schubert-loving models, Patrick Nowlin and Ariana Karp. I am indebted to Sarah Schaffer, John Schaffer, and John Wiley for their support and interest in this project and to Steve Salemson of the University of Wisconsin Press for running a tight ship in the uncharted waters of such a complex collaboration. I must thank my family and friends for their loyal support and understanding in those weeks when floors and tables were covered with prints, and rooms were literally roped off. Thanks also go to Jennifer Hirsch for the equine loan, the Talbot-Czolbe family for the canine loan, Doug Hill for loan of an authentic post horn, and John Harbison for his poetic contribution to *Die Post*.

—Katrin Talbot

CONTRIBUTORS

Photo: Katrin Talbot

MARTHA FISCHER is professor of piano at the University of Wisconsin–Madison School of Music, where she heads the collaborative piano program. A sought-after accompanist and chamber musician, she has performed throughout the United States and Europe with many nationally recognized singers and instrumentalists. With a particular devotion to Franz Schubert's lieder and chamber music, she co-founded Schubert Ensembles in Boston and Washington, D.C. She has served as Artistic and Music Director for Opera for the Young, an organization dedicated to bringing fully staged professional operatic performances to school children throughout the nation. Ms. Fischer holds degrees in piano from Oberlin College and the New England Conservatory of Music. She and her husband, Bill Lutes, frequently collaborate in concerts of two-piano and piano duet literature. Ms. Fischer is also a singing actress and an authority on the operettas of Gilbert and Sullivan. She and Mr. Lutes have toured North America with their revue *Innocent Merriment: An Evening of Gilbert and Sullivan*. A dedicated teacher, Ms. Fischer has presented papers and served on national panels devoted to the pedagogy of collaborative piano.

Pulitzer Prize–winner JOHN HARBISON is one of America's most prominent composers. More than fifty of his works—which include four string quartets, three symphonies, three operas and a cantata—have been recorded on leading labels such as Harmonia Mundi, New World, Deutsche Grammophon, Decca, and Koch. Born in New Jersey, he earned an undergraduate degree from Harvard and an MFA from Princeton before joining the Massachusetts Institute of Technology as Institute Professor. Along with the Pulitzer Prize, Mr. Harbison has been awarded the Kennedy Center Friedheim First Prize, a MacArthur Fellowship, the Heinz Award, and four honorary doctorates. Mr. Harbison has been composer-in-residence with the Pittsburgh Symphony, the Los Angeles Philharmonic, the American Academy in Rome, and numerous music festivals, including Tanglewood, Marlboro, and

Photo: Katrin Talbot

Aspen, and he has premiered works with the Metropolitan Opera, the Chicago Symphony, and the Boston Symphony. He currently performs as the principal guest conductor of Emmanuel Music in Boston, has just completed his *Requiem* for the Boston Symphony Orchestra and his *Second Piano Sonata*, and is at work on his *Fourth Symphony*, a piano trio, and a two-piano concerto. He and his wife, Rose Mary, reside part-time near Madison, Wisconsin, where they direct the annual Token Creek Chamber Music Festival.

JOHANN LUDWIG WILHELM MÜLLER was born in 1794 in Dessau and was the only surviving child of tailor Christian Leopold Müller and his wife Marie Leopoldine Cellarius Müller. Wilhelm Müller studied philology, literature, and history at the University of Berlin, but left in August 1817 for travels in Austria and Italy. Upon his return to Dessau in January 1819, he became town librarian, teacher, editor, translator, critic, and poet. Dubbed "the German Byron," he was a passionate supporter of the Greeks in their struggle for independence from the Ottoman Empire, and his fame in the nineteenth century was based largely on his *Griechenlieder* (Greek songs), written between 1821 and 1826. Much of his lyric poetry is contained in two companion volumes: the *Siebenundsiebzig Gedichte aus den hinterlassenen Papieren eines reisenden Waldhornisten* (Seventy-seven poems from the posthumous papers of a traveling horn player) of 1821 and the *Gedichte aus den hinterlassenen Papieren eines reisenden Waldhornisten II: Lieder des Lebens und der Liebe* (Poems from the posthumous papers of a traveling horn player, vol. 2: Songs of life and love) of 1824. (The earlier collection was the source for Schubert's song cycle Die schöne Müllerin.) He also translated Christopher Marlowe's *Tragicall Historie of Doctor Faustus* into German, edited ten volumes of seventeenth-century German poetry, and wrote reviews of Italian travel, lore, and contemporary poetry. After his return from travels along the Rhine River, he died in his sleep on the night of 30 September 1827.

Photo: Katrin Talbot

Born and raised in Florida, baritone PAUL ROWE received his Bachelor of Music degree from Stetson University and a Master of Music degree and Performer's Certificate from the Eastman School of Music in Rochester, New York. His wide-ranging performing career throughout the United States over the past twenty years has included performances with many major American musical organizations, including the Boston Symphony, the St. Louis Symphony, the American Ballet Theater, the Madison Symphony, Musica Sacra, the Smithsonian Chamber Players, and the Waverly Consort. As a member of the Waverly Consort, he toured the United States, the Far East, and South America and participated in the Consort's regular series at Alice Tully Hall and the Cloisters in New York. Specializing in the music of J. S. Bach and Schubert, Paul Rowe regularly sings opera and oratorio, and in recital he has sung a wide variety of music from early to contemporary works. He is currently Associate Professor of Music in Voice at the University of Wisconsin–Madison, as well as a founder and artistic director of the Madison Early Music Festival.

FRANZ PETER SCHUBERT was born in Vienna on 31 January 1797 at what is now 54 Nussdorferstrasse as the son of a schoolmaster named Franz Theodor Florian Schubert and his wife Maria Elisabeth Katharina Vietz. In late 1808, Franz Schubert was accepted as a choirboy in the imperial court chapel and schooled at the Imperial and Royal City School; one of his composition teachers was Antonio Salieri. By late 1813, he left the imperial college to enter a training school for teachers and by autumn 1814 was teaching in his father's school. Unhappy as a teacher, he left teaching altogether in the summer of 1818 and worked thereafter as an independent composer. Perhaps in late 1822, under circumstances no one knows, he contracted syphilis; six years later, his health broken, he died during the night of 19 November 1828 in his brother Ferdinand's apartment on Kettenbrückengasse. Not quite thirty-two at the time of his death, he left a prodigious quantity of extraordinary music in a vast array of different genres: chamber music, opera, symphonic composition, sacred and secular choral works, masses, sonatas and smaller-size works for piano, and more than six hundred songs.

Australian-born KATRIN TALBOT is a photographer and violist who often combines these two areas. She received a BA from Reed College and an MS in molecular biology from the University of Wisconsin–Madison. Her photography has appeared in many national exhibits in museums and galleries and has won several national prizes, including the top prize at the Hoyt Institute National juried all-media exhibition. Her work was selected by Peter Plagens, art critic for *Newsweek*, for part of an exhibit in the Holter Museum in Montana, and recently her photographs have been part of national exhibitions in three New York City galleries. Her recent music-related photography has been used by the Metropolitan Opera, the Boston Symphony, the Santa Fe Chamber Music Festival, Lincoln Center, the Cincinnati Opera, the Madison Symphony, Warner Brothers Publications, the Red Hot Lava Chamber Music Festival, and the CD companies CRI and Musica Omnia. Her work has also appeared in many newspapers and magazines. She is married to cellist Parry Karp, and they have three daughters, who have frequent in-house modeling duties.

Photo: Ariana Karp

Photo: Ingrid Cowan

Mezzo-soprano LOUISE MCCLELLAND URBAN, Professor Emerita at the University of Maryland, College Park, pursued her early love of German lieder as a Fulbright scholar at the Vienna Hochschule, from which she holds performance degrees in Lied, Opera, and Oratorio. She has appeared as soloist with the Cleveland Orchestra, the Casals Festival Orchestra in San Juan, the Austrian Radio Orchestra in Vienna, and the National Symphony in Washington, D.C. Well-known as a recitalist with a special interest in the songs of Hugo Wolf and Franz Schubert, she has given concerts at the Salzburg Mozarteum, the Freiburg Festwochen, Carnegie Recital Hall, the Library of Congress, and the National Gallery of Art. Ms. McClelland is a frequent clinician and master class teacher around the country, and this past summer marked her twelfth season on the Opera Theater faculty at the Fairbanks Summer Arts Festival. In 1987 she was awarded the Hugo Wolf Medallion by the International Hugo Wolf Society in Vienna for her performance and teaching of Wolf's music, and in 1991 Schirmer Books published her translated edition of the composer's letters to Melanie Köchert, reissued in paperback in 2003 by the University of Wisconsin Press.

SUSAN YOUENS was born in Houston, Texas, and educated at Southwestern University and Harvard University. She has taught at Washington University in St. Louis, Ithaca College, and the University of Notre Dame, where she is presently Professor of Musicology. Her books on German song include *Retracing a Winter's Journey: Schubert's Winterreise* (Cornell University Press, 1991); *Schubert: Die schöne Müllerin* (Cambridge University Press, 1992); *Hugo Wolf: The Vocal Music* (Princeton University Press, 1992); *Schubert's Poets and the Making of Lieder* (Cambridge University Press, 1996, reprinted 1999); *Schubert, Müller, and Die schöne Müllerin* (Cambridge University Press, 1997); *Hugo Wolf and His Mörike Songs* (Cambridge University Press, 2000); and *Schubert's Late Lieder: Beyond the Song Cycles* (Cambridge University Press, 2002). She is currently working on two books, one about songs to poetry by Heinrich Heine and the other a social history of the lied.

Photo: Katrin Talbot

Winterreise CD track times

1.	Gute Nacht / Good Night	5:39
2.	Die Wetterfahne / The Weather Vane	1:49
3.	Gefror'ne Tränen / Frozen Tears	2:31
4.	Erstarrung / Numbness	3:12
5.	Der Lindenbaum / The Linden Tree	4:49
6.	Wasserflut / Floodwaters	4:29
7.	Auf dem Flusse / By the Stream	3:35
8.	Rückblick / Backward Glance	2:31
9.	Irrlicht / Will-o'-the-Wisp	2:41
10.	Rast / Rest	3:45
11.	Frühlingstraum / Dreams of Spring	4:19
12.	Einsamkeit / Loneliness	2:38
13.	Die Post / The Mail	2:25
14.	Der greise Kopf / The Aging One	3:22
15.	Die Krähe / The Crow	1:56
16.	Letzte Hoffnung / Last Hope	2:12
17.	Im Dorfe / In the Village	3:15
18.	Der stürmische Morgen / The Stormy Morning	0:56
19.	Täuschung / Delusion	1:25
20.	Der Wegweiser / The Signpost	4:36
21.	Das Wirtshaus / The Inn	4:41
22.	Mut / Courage	1:26
23.	Die Nebensonnen / The Phantom Suns	3:04
24.	Der Leiermann / The Hurdy-Gurdy Player	3:55
	Total time:	75:11